Colour

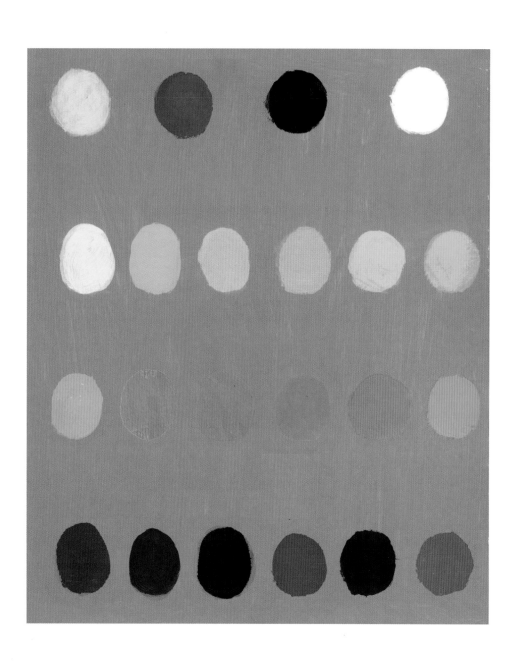

Colour

A workshop for artists and designers

Second Edition

David Hornung

Laurence King Publishing

For Rosie and Henry

First published in 2005
Second edition published in 2012 by
Laurence King Publishing Ltd
4th Floor, 361–373 City Road
London EC1V 1LR
Tel: +44 20 7841 6900
Fax: +44 20 7841 6910
email: enquiries@laurenceking.com
www.laurenceking.com

This book was produced by Laurence King Publishing Ltd

A catalogue record for this book is available from the British Library

ISBN: 978-1-85669-877-1

Commissioning Editor: Kara Hattersley-Smith
Editor: Sarah Batten
Picture Researcher: Ida Riveros
Design by David Hornung
Cover design by Jason Ribeiro
Layout production assistance by Lozana Rosenova

Printed in China

CONTENTS

ACKNOWLEDGMENTS

In creating this second edition of *Color*, I have drawn on the support and encouragement of many friends and colleagues. Foremost, I want to thank Laurence King for initially encouraging me to write a second edition, and for allowing me the freedom to make all the improvements I felt were necessary.

I would also like to recognize the contribution of Kara Hattersley-Smith, editorial manager at Laurence King, who organized the project from its inception and whose assistance and patience were essential to the book's progress. As it was nearing completion Sarah Batten took over the reigns and helped shepherd the project into production.

I would also like to thank Robert Shore, who edited both editions; Simon Walsh, production manager, for insuring that the color throughout the book is as good as it can be; and Ida Riveros, picture editor, who procured the images I needed from outside sources to illustrate the text. Thanks also to my reviewers, whose critical insights on the first edition helped me make many improvements in the second.

I am grateful to my colleague Jennifer Maloney, who gave the entire text a close and critical reading. Lozana Rosenova deserves special acknowledgment for her steadfast and able assistance in putting this book together from beginning to end.

Finally, I want to express my gratitude to all of my color students who, over the years, have provided me with an education.

PREFACE

One would think that a condition of the physical world as omnipresent as color would be easy to understand. Because it is a function of light, however, and because light is highly variable, color is one of the most elusive and enigmatic elements for the artist and designer to master.

David Hornung has brought his long experience as a visual artist to the task of demystifying the phenomenon we call color and making it accessible to the art and design student. He wisely avoids the tendency of color theorists to systematize color and opts for a hands-on experience that is both practical and logical. He recognizes from his own studio career that colorists don't spring to life with some fully formed capacity to compose color and to communicate with it. Rather, they develop confidence in working expressively with color through a dedicated and disciplined practice experienced at the tip of a brush or pen or pencil, through cut or torn collage elements, or via pixilated images on a computer monitor.

Color language is quite specific and efficient, and Hornung is careful to define and to illustrate the terms we commonly use to describe characteristics or aspects of color and color usage. From semantic misunderstandings or misreadings arise many of the problems associated with color study, but here the student will find a rigorous yet streamlined analysis of that language designed to avoid just such misinterpretations.

I have been fortunate on a number of occasions to visit David Hornung's color classes at the Rhode Island School of Design, to sit in on critiques of student work, and to look closely at student portfolios from those classes. One of the many strengths of his pedagogical approach is that it is flexible enough to allow for, in fact to encourage, explorations through a broad range of visual structures. This democratic sensibility makes the work comfortable for students in widely varying disciplines. The experience of color that each student engages in through the exercises documented in this course of study provides a solid grounding for professional activity in all visual fields.

This book will serve as both a manual of self-guided study as well as a handbook for directed study under the guidance and oversight of an experienced artist. As such it deserves a place alongside the classics of color literature such as Josef Albers' *Interaction of Color* and Johannes Itten's *The Art of Color*. Its clarity, accessibility, and practicality make it an ideal complement to those universally respected studies.

Michael James
Ardis James Professor of Textiles, Clothing and Design
University of Nebraska at Lincoln, Nebraska

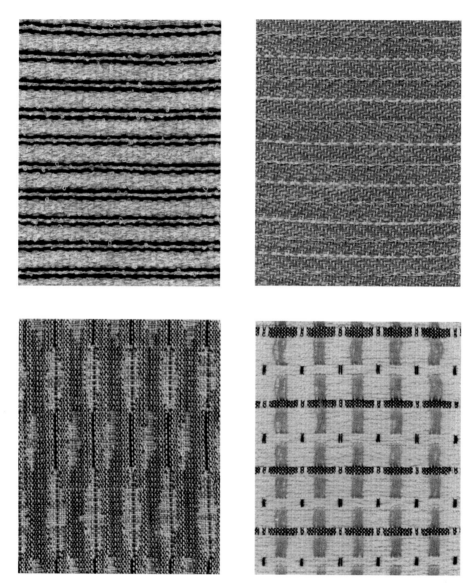

Lydia Neuman, weave samples. Courtesy of the Artist.

FOREWORD

Fifteen years ago, a fellow student at Rhode Island School of Design showed me a group of small paintings she had done in a class with David Hornung. She called them her "Wonder Bread Dots." As I looked through the work – page after page of gouache gumballs perched inside six-inch colored squares – I knew I had to take David's class. Poetically titled "Handmade Light," it was the color theory course I'd always hoped for.

David's approach hinges on the recognition of three constituent parts of color. Hue is what we generally mean when we talk about color – the redness or blueness of something. Value, or quantity of light, describes lightness or darkness – how a color would look on a grayscale, or in a black-and-white photograph. And finally, saturation refers to quality of light – a color's relative brightness, or purity of pigment. In order to illustrate this last, most elusive concept, David had us mix countless "chromatic grays" – colors that look neutral but contain only red, yellow, and blue (both warm and cool) in various proportions. It would be difficult to overstate the value of this exercise, which confers a superpower of sorts – a kind of x-ray vision that allows you to see grays, browns, and even whites in terms of their primary color ingredients.

Referencing sources from Europe to Asia to the Americas, from paintings to woodcuts to textiles, from the ancient to the contemporary, from folk art to Modernism, David demonstrates that the mechanics of color transcend time, geography, media, subject, and style.

My own perception of color has always felt like a kind of synesthesia that blends sight and taste – or more precisely, thirst. Looking at an unfinished or not-quite-right color arrangement, I automatically ask myself what it's thirsty for. The answer has always come from instinct, as I suspect it does for many artists. David's analytical vocabulary helped me to articulate such visceral responses. Color theory turned out to be color practice – the rigorous, simultaneous exercise of intuition and intellect. David's gift is that he makes this ephemeral subject concrete, but no less magical; his structural approach to color affords access to its emotional valence.

For me, color is not a surface characteristic, but a quality of light that suggests season, place, climate, and corollary psychological landscapes. I make textiles – weavings and quilts – that are opaque and low-tech, so I use color to make light "by hand" as it were. Light is the real stuff of the explorations in this book. David's course transforms one's love (or fear) of color into surefooted facility.

Lydia Neuman
Printmaker, textile artist, and color consultant
Austin, Texas

INTRODUCTION

This second edition of *Color: A Workshop for Artists and Designers* is based upon a course of study that I originally developed at the Rhode Island School of Design. Over the past 22 years, I have had the opportunity to teach this course at several colleges including RISD, Brooklyn College, and Adelphi University as well as in short-term workshops for professional artists in the United States and Canada.

The first edition was published in 2005. It presented the color curriculum I had refined over the years while working with textile designers, weavers, quiltmakers, graphic designers, painters, and illustrators. The intended audience of both editions is the professional artist or professional-in-training whose understanding of color theory must be linked to studio practice.

The second edition improves on the first in a number of ways. First, its larger format allows for more readable visual examples. Second, there are many new images that enhance the book's clarity and usefulness. Third, a significant amount of new text has been added to further refine ideas and explanations introduced in the first edition. Here is a summary of some of the improvements made to each chapter:

Part I: Seeing Color

Some of the diagrams have been remade to improve clarity and conceptual consistency. A new illustration of the "white paper test" that demonstrates the effect of changing light on the appearance of colored surfaces is now included. Information has been rearranged and new text added.

Part 2: First Principles

The color wheel has been redesigned to improve its comprehensibility and the text is revised and expanded with regard to several key concepts, e.g., the semantics of color terminology, color temperature, and the relationship between value and luminosity. Other important changes include more focused discussions of color schemes, color range, inherent light, color continua, and color proportion.

Part 3: Materials and Techniques

This new chapter gives a complete explanation of materials and techniques needed to engage in the assignments. Also included is a helpful new discussion of the grayscale and its use in making color studies.

Part 4: Beginning Color Studies

This chapter begins with a new examination of color nomenclature. Assignments open with a pedagogical rationale and there is a new discussion of "keying" color. Visual examples are more closely linked to the text and are larger and clearer.

Part 5: Color Interaction

Two major additions have been made to this chapter: a discussion of limited color and a section that deals with the effect outlining colors has upon their interaction. New illustrations accompany these added topics.

Part 6: Applying Color Principles

The new title for this section is more descriptive of its contents which include in-depth discussions of color progression, retinal painting, the effect of color on pictorial space, and the illusion of transparency. Near the end of the chapter is a new discussion of the effect changing attitudes about color had on the development of abstract painting in the early twentieth century.

Part 7: Color Harmony

In this chapter, the concept of color harmony is based on a musical model that views sonic relationships ranging from the concordant to the discordant as a matter of fact with no preference attached to either extreme. Color "harmony" is analyzed in terms of hue, value, and saturation. Assignments are more clearly organized than before and the explanatory text has been rewritten for greater clarity. The chapter ends with four examples of color harmony drawn from both contemporary and historical sources.

Part 8: Color Research

This chapter begins with an expanded description of color sources and follows this discussion with a more thorough explanation of both proportional and nonproportional color inventories. Visual examples have also been improved. A new section on the value of describing color is supported by four illustrated examples followed by eight descriptions of free studies made by students.

Part 9: Color Experience and Interpretation

This chapter, formerly called "The Psychological Experience of Color" now includes a more developed discussion of color symbolism and analogy. The subsection titled "The Psychological Effect of Color Relationships" focuses on the way we are affected by color groupings with examples from both fine art and advertising. The last four pages are devoted to a brief exploration of color in three-dimensional art.

Part 10: Color Studies on the Computer

Computer studies that revisit the hand-made assignments from previous chapters can strongly fortify one's understanding of color principles. Several examples of digital art support a discussion of the place of the computer in the contemporary artist's studio. The discussion of RGB and CMYK and their relationship to additive and subtractive color theory has been expanded and the illustrations accompanying assignments have been improved.

Using this Book

This book is intended as a guide to a practical workshop in color. I strongly recommend working through these studies in sequence and following the "story" of color as it unfolds in these pages.

The book can also be of value as a reference manual. The illustrations, many of them made by students, help the text explain color concepts that are, even if only read and studied, of practical use for artists and designers who use color in their work.

1. SEEING COLOR

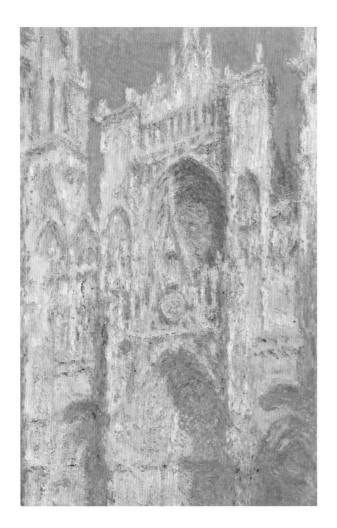 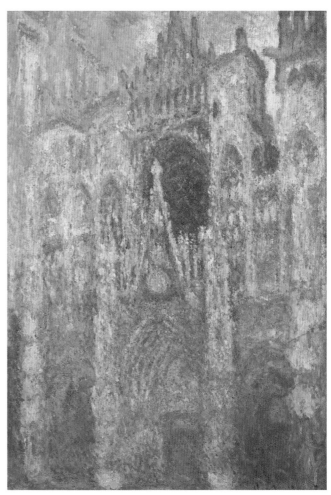

"Color is my day-long obsession, joy, and torment."

Claude Monet

Color is said to be contained within light, but the perception of color takes place in the mind. As waves of light are received in the lens of the eye, they are interpreted by the brain as color.

Colors that seem similar (such as orange and yellow-orange) do so because their wavelengths are nearly the same. Wavelength in a ray of light can be measured on a nanometer:

red	orange	yellow	green	blue	violet
780 – 658 nm	658 – 600 nm	600 – 567 nm	567 – 524 nm	502 – 431 nm	431 – 390 nm

A ray of sunlight can be conceived of as being divided, like a rainbow, into a continuum of color zones. Each color zone contains more gradients than the mind can distinguish. The boundaries between colors are blurred, not sharply delineated. In the example below (fig. 1.1), the color yellow extends from the edge of yellow-orange on one side, across to where yellow merges into yellow-green on the other.

1.1 The full gamut of the the the hue yellow extends from golden yellow (leaning toward orange) to lemon yellow (leaning toward green).

The perception of colored surfaces is caused by the reflection of light from those surfaces to the eye. A lemon appears "lemon yellow" to us because its molecules reflect light waves that pulsate at approximately 568 nm while predominantly absorbing waves of other frequencies. Lightwaves that are not reflected are not perceived as color (fig. 1.2).

1.2 On a yellow surface, the yellow wavelengths are reflected while other colors are absorbed and are therefore not perceived.

Color sensation can also be caused by gazing, directly or indirectly, at colored light. When different colored lights are combined (as on a theater set), the combination adds luminosity or brightness. Hence, light intermixing is considered an ADDITIVE COLOR* process.

In contrast to mixing colored light, the intermixture of spectral colors in pigment tends to produce colors that are duller and darker than those being combined. (Spectral colors are those that approach the purity of colors cast by a glass prism or seen in a rainbow.) The more unalike the pigments being mixed, the darker the result. Darkness means less LUMINOSITY, thus mixing pigments is a SUBTRACTIVE COLOR process.

Intermixing pigments darkens color because the reflection and absorption of color in pigment are never absolutely pure. Although lemon yellow, for example, does reflect the yellow part of the SPECTRUM, its absorption of other colors is not total, as suggested in figure 1.10 on page 17. We see yellow predominantly, but subtle color reflections of all the other colors are also present. In the case of lemon yellow, a greenish cast is visible. (The diagram at right, figure 1.3, gives a truer picture of light reflected from a lemon-yellow surface.)

COLOR OVERTONES AND THE PRIMARY TRIAD

Throughout the history of color theory, there has been a tendency to arrange the HUE CONTINUUM in a circle. The extremities of the continuum, infrared and ultraviolet, resemble each other and seem to complete the sequence of HUES that proceeds gradually across the color zones of the spectrum. There is also, admittedly, a satisfying wholeness and symmetry to the circular configuration that suggests a sense of timeless rectitude. It also happens to distribute the hues in a way that facilitates an understanding of their relationships (fig. 1.4). When hues are arranged in a circle, one triad is considered more elemental than any other: the PRIMARY TRIAD of red, yellow, and blue.

While an infinite number of such triangles reside within the spectrum, the primary triad is unique because red, yellow, and blue are each, in theory, indivisible. They cannot be made by combining other colors. Conversely, all other colors can be made by combining two or more colors of the primary triad. But, as with our initial comments on color reflection, this is an oversimplification. Any color mixture also includes, along with the intended colors, their subsidiary color reflections. The simplicity and symmetry of the primary triad have a powerful appeal and, for some, an elemental significance.

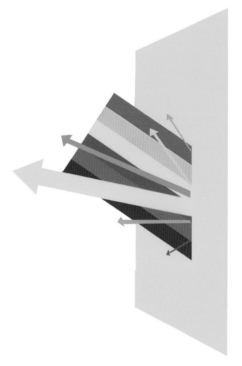

1.3 Color absorption in pigments is not total. Lemon yellow, for example, reflects visible amounts of green and smaller, less perceptible amounts of other colors.

1.4 The primary triad forms an equilateral triangle on the spectral continuum.

* Color terms that can be found in the illustrated glossary (pp. 154–164) appear in capital letters when they are first encountered in the text.

The idea that one can mix all possible colors from the primary triad is based on the assumption that there are pure pigments that represent the true primary colors. Unfortunately, none really exist. All red, yellow, and blue pigments are visually biased, to a degree, toward one or another of the colors that adjoin them.

It is commonly understood, for example, that green can be mixed by combining blue with yellow. But to make a vivid, seemingly pure green would be impossible if the only blue available were ultramarine. An even duller green would result if the mixture were based upon a combination of ultramarine blue and yellow deep (fig. 1.5).

Both ultramarine blue and yellow deep are biased toward colors that contain red (violet and orange, respectively). Red lies opposite green on the COLOR WHEEL. Colors that oppose each other directly on the color wheel are called COMPLEMENTARY HUES. Mixing complementary colors lowers the SATURATION (richness) and VALUE (luminosity) of the resulting tone. In other words, it has a dulling and darkening effect. Mixing ultramarine blue and yellow deep adds a latent red (the subsidiary reflections of both colors) which dulls and darkens the resulting green (fig. 1.5).

To mix a vivid green, choose lemon yellow and sky blue (fig. 1.6). Both are biased toward green and reflect insignificant amounts of red.

It should be understood that this discussion pertains to the mixing of pigments and, in particular, to the generation of secondary colors from the intermixing of primary colors. We don't mean to suggest that all colors are physically achieved by combining primaries. To describe a green as "containing" blue is only literally true if that green has been made by intermixing blue and yellow pigments. Some pigments appear green in their pure physical form, e.g. chromium oxide green, but physically contain no blue. But all greens contain blue visually, and the blue element comes into play with color interaction, which we will cover in depth in Part Five.

A Musical Analogy

In this course we call a color bias an OVERTONE, a term borrowed from music. When a C string is plucked on a harp or struck on the piano, the string vibrates at a specific rate that causes our ears to hear a C. But in addition to the C, we also hear a weaker vibration: a G and (more subtly) an E (fig. 1.7). In fact, a diminishing succession of subvibrations always accompanies the strong pitch of a plucked string. As when colors are mixed, when individual musical tones are combined, so are their overtones. The result is a denser sound than one might expect. Adding a third and fourth note thickens the harmonic texture. The role of color bias in mixing paint parallels this acoustical phenomenon.

1.5 The color overtones of ultramarine blue and yellow deep make it impossible to mix a vivid, spectral green from them.

1.6 When lemon yellow and sky blue are mixed, a vivid green can result because both are biased toward green.

1.7 Each plucked note is accompanied by a series of subsidiary acoustical overtones.

Mixing a Secondary Triad

If we try to mix a vibrant SECONDARY TRIAD (orange, green, and violet) from a primary triad consisting of one specific red, one blue, and one yellow, some of the results will be compromised by conflicts in the colors' overtones. Consider a primary triad composed of warm red (orange overtones), warm yellow (orange overtones), and cool blue (violet overtones) as shown in figure 1.8. A strong, clear orange would be possible because these particular reds and yellows both lean toward orange (fig. 1.9). But vivid violets and greens present a problem because the combinations necessary to create those colors contain overtones that conflict with the desired result. For pure violet, it is the right blue but the wrong red. For bright green, neither this blue nor this yellow is appropriate.

To overcome these limitations it might seem reasonable to create a primary triad by combining two versions of each primary color, each with a different bias. For example, by mixing sky blue (green overtones) with ultramarine blue (violet overtones), one can obtain a more neutral blue, one that has only the smallest discernible bias toward either green or violet. However, mixing secondary colors from such "neutral" primaries tends to split the difference, producing no mixtures that are ever quite lucid enough, but also none that are extremely dull. Truly vivid secondaries can only be achieved with primary colors that are *both* biased toward the target.

A CO-PRIMARY TRIAD

The most practical solution is to work from a primary triad consisting of six rather than three colors with two versions of each primary hue. We call these six colors CO-PRIMARIES.

1.8 Intermixing these primaries (warm red, warm yellow, and cool blue)…

1.9 …produces these secondaries.

The co-primaries consist of warm and cool versions of red, yellow, and blue. All six co-primaries are shown below (fig. 1.10) surrounded by their overtones.

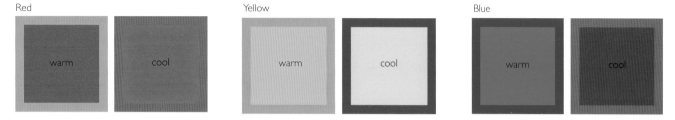

Red Yellow Blue

warm cool warm cool warm cool

1.10 The six co-primaries, shown surrounded by their overtones.

Co-primaries can be intermixed to produce a full set of spectral colors and TONES derived from them. The addition of permanent white expands tonal possibilities further. But, even with co-primaries, there are still limitations. Some vivid secondary and TERTIARY COLORS, e.g. violet, will be unobtainable through intermixing.

Violets are mixed from the two darkest primary colors (blue and red). The results are often dark and difficult to read; when the goal is a "pure" violet, those obtained through mixing will always be a little disappointing.

Commercial violets, made directly from a violet pigment, are clearer than those made by color mixing. However, for consistency, it is better, in the first four assignments in this course at least, to mix violets than to purchase them. The conceptual benefits gained by maintaining the palette's symmetry outweigh the richness of hue obtained by the addition of a commercial violet.

The colors for all the assignments in Part Four should be mixed solely from the six co-primaries plus white. As the course progresses, an EARTH-TONE PRIMARY TRIAD (burnt sienna, yellow ocher, and Payne's gray) should be added to the palette (fig. 1.11). Earth tones are easy to mix from the original co-primaries, but we suggest that you buy them premixed for economic reasons.

1.11 An earth-tone primary triad:

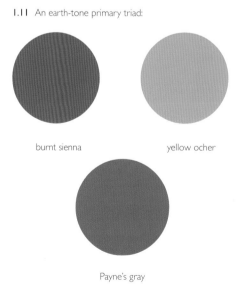

burnt sienna yellow ocher

Payne's gray

THE INFLUENCE OF LIGHT ON REFLECTED COLOR

So far, our discussion of reflected light has focused on the effect of direct sunlight. In relatively unfiltered sunlight, like that seen around noon on a cloudless day, the full spectrum of color frequencies, from infrared to ultraviolet, is present.

At other times, such as early morning or late afternoon, particular colors are filtered out by the atmosphere. Variations in the color of light are most evident in lighter colors (tans, light grays, yellows, etc.). Other atmospheric conditions like heavy cloud cover or air pollution also limit the range of available light waves.

Artificial Light

Artificial light is sometimes called reduced-spectrum lighting because it is deficient in some color frequencies found in sunlight. Incandescent bulbs, for example, yield a warm light that is strong in the yellow, orange, and red frequencies. On the other hand, fluorescent lighting tends toward the cool frequencies and casts an illumination that favors blues and greens.

Warm pigments will appear more vivid under incandescent lighting and somewhat deadened under fluorescent light. Cool colors, especially blues and greens, will appear livelier under fluorescent light.

For a clear demonstration of the hue bias of various light sources, carry a "white" piece of typing paper from a window to an incandescent lamp, and then to a fluorescent light. Examine the shifting temperature of the page as you move from one light source to another (fig. 1.12).

Theatrical Lighting

Dramatic extremes in lighting can have a profound effect on color perception. If squares of green and yellow (fig. 1.13) are lit by a strong blue light, the green is a rich blue-green, but the yellow appears black because its molecules reflect an imperceptible amount of the focused blue frequency. It is as if the yellow is not illuminated at all (fig. 1.14).

This is the essence of stage lighting, which can make the same set appear dramatically different by shifting the color of the light source to amplify or repress various colors on the set in concert with the narrative.

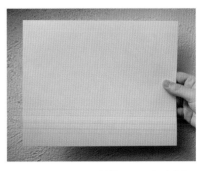

White paper in daylight...

...under incandescent light...

...and under fluorescent light.

1.12

1.13

1.14 The effect of blue light cast upon the green and yellow squares of figure 1.13.

Standard Lighting

Today, most two- and three-dimensional art and design is viewed under natural light, artificial gallery lighting, or reading light. Whatever the artificial light source, it is typically relatively warm in temperature.

Package designs may be the exception since they are often initially encountered under the cool fluorescent lighting one finds in supermarkets and large pharmacies. (Even fluorescent lighting has become warmer in recent years.)

Interior designers are most aware of the relationship between light, space, and surfaces. In their work, light itself becomes a design element.

We recommend that color studies made for this course be executed under lighting conditions similar to those in which they will be evaluated.

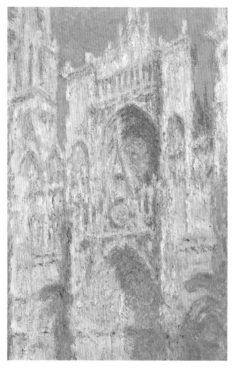

1.15 Claude Monet, *Rouen Cathedral. West Façade, Sunlight,* 1894, oil on canvas. Chester Dale Collection, National Gallery of Art, Washington, D.C.

Monet's Experiments

In the late winters of 1892 and 1893, Claude Monet painted over 30 pictures of Rouen Cathedral. Two of them are reproduced here (figs. 1.15 and 1.16). This series of images, along with several similar experiments with other subjects, e.g. a field of haystacks, poplars, and the Houses of Parliament in London, was Monet's attempt to paint light itself. He wanted to demonstrate the effect that changing light and atmospheric conditions have upon the color of an object.

Monet's studies of Rouen Cathedral address its architectural façade from virtually the same vantage point each time, unlike his earlier and equally well-known series of haystack paintings in which the landscape is seen from a variety of angles and distances. Making the point of view more uniform from picture to picture clarified his intent. The scientific notion of a "control" against which other variables can be clearly observed seems rather modern, as was Monet's attempt to elevate his somewhat clinical interest in the effects of light to a fitting subject for a work of art.

Interestingly, the near-frontality of the cathedral's façade in these pictures presents its structural lines as a grid, foreshadowing the grid-based compositions of later painters like Piet Mondrian, Richard Diebenkorn, and Gerhard Richter.

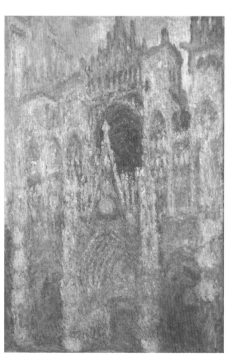

1.16 Claude Monet, *Rouen Cathedral, the West Portal and the Tour d'Albane, Harmony in Blue,* 1894, oil on canvas. Musée d'Orsay, Paris.

2. FIRST PRINCIPLES

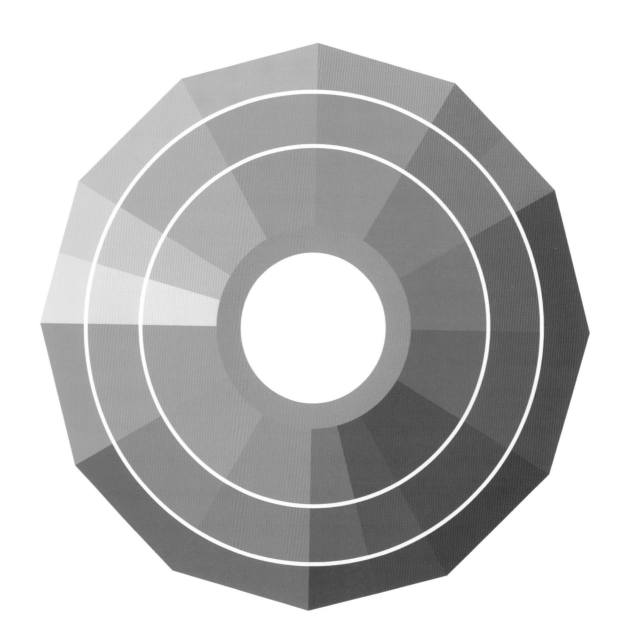

"Color exists in the visual field. This two-dimensional universe, separate from the three-dimensional world of touch, operates according to rules of its own."

Patricia Sloane

ABOUT COLOR TERMINOLOGY

Although color theory has its basis in the science of optics, it is also subject to practical considerations and critical preferences that make universal agreement impossible. Much of the confusion comes from disagreements about color terminology. For example, the term "tertiary colors" usually applies to intermediate colors that fall exactly between each primary and secondary color on the color spectrum. But some theorists prefer to use the term for colors achieved by mixing all three primaries.

Another example: The quality of color known as saturation is also sometimes called "intensity" and sometimes "brightness." Albert Munsell, the great American color theorist of the late 19th and early 20th centuries, preferred the term "chroma." We choose "saturation" both because it seems the most descriptive and for a practical reason: It is employed by Adobe in its Creative Suite software package. Since the mid 1990s, "saturation" has become the dominant term for the richness of a color.

Whatever terms are used, consistency is important. To facilitate communication, it makes sense to use the most common term whenever possible. Through study and experience you will gradually become familiar with variations in color terminology and be able to distinguish substantial disagreements about color theory from more trivial preoccupations with semantics.

Despite these controversies, however, the majority of color terms enjoy broad agreement and are applied throughout the visual arts. We do employ two terms, which, while not exclusive to this text, are not widely used. CHROMATIC GRAY and MUTED COLOR serve a purpose that no common term answers: the need to make categorical distinctions within the phenomenon of saturation. The particular emphasis we give to saturation in this course requires the adoption of these terms and you will find them very useful.

THE STRUCTURE OF COLOR

Most people are aware that colors have more than one visible quality. In everyday language, color names, such as "red," are often coupled with adjectives. Expressions like "fiery red," "cherry red," or "blood red" reflect the fact that colors have characteristics not adequately represented by a broad color name alone. (We will discuss color nomenclature at greater length in Part Four.)

All colors possess three distinct, fundamental factors that account for their appearance. Each can be manipulated independently, either by color mixing or, more subtly, by altering the context in which the color appears. These factors are called hue, value, and saturation.

HUE

When we refer to a color on the spectrum by its name, we are referring to its hue. The color spectrum is a continuum of infinite hues, each one having a unique wavelength. The continuum contains recognizable hue zones that shift gradually into each other. Their boundaries are ambiguous, so precise hue identity is particularly difficult to ascertain in those transitional areas. Theoretically, at the heart of every zone is the pure, true version of each hue. Of course, since each position on the spectrum is infinitely divisible, there can be no actual zonal center. The idea of a true red, blue, and yellow is an impossible abstraction that can only exist in the mind.

Most of us have a firm mental picture of hue identity, especially with the primary and secondary hues. But it is very much a personal conception. For example, the emblematic blue that most of us carry in our heads differs from individual to individual. Looking at the full spectrum, one sees that within each hue zone is a color shift that echoes our discussion of color overtone on pages 14 and 15. In the blue zone, blueness extends from blue-green on one side to blue-violet on the other. Is your conception of "pure blue" closer to sky blue (shifting toward blue-green) or ultramarine blue (shifting toward blue-violet)?

Color Temperature

Color shifts within a hue zone are sometimes described in terms of "temperature." COLOR TEMPERATURE is either "cool" or "warm" and is strictly an aspect of hue. Consider the hue continuum depicted as a circle (fig. 2.1). The circle can be divided roughly in half: warm colors stretching from red-orange to yellow-green, and cool colors from red-violet to blue-green.

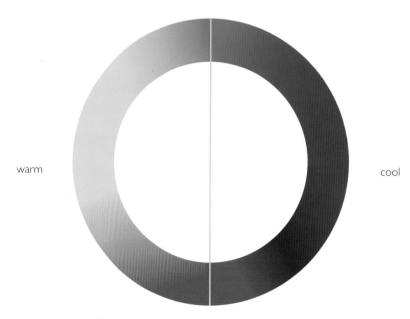

warm cool

2.1 The hue continuum bisected according to temperature.

The psychological association that ties color temperature to specific hues is probably based upon fundamental associations we make with the elements of physical existence, like fire and ice.

Color temperature is also contingent on its surroundings. While cobalt blue resides on the cool side of the spectrum and would appear cool in the company of oranges and yellows, it can appear warm when surrounded by blue-violet (fig. 2.2). Furthermore, a warm color like yellow nevertheless exhibits a temperature shift across its spectral zone. As it moves toward orange, it gets warmer; going toward green, it gets cooler. Scarlet or flame red is generally regarded as warmer than crimson, and sky blue is considered warmer than ultramarine blue. The co-primaries we use in this course consist of cool and warm versions of each primary hue.

Visualizing the Hue Continuum

When envisioning color, it is helpful to have a mental picture of each color factor (hue, value, and saturation) and to be able to speculate upon them as both distinct and interrelated. Each factor is a continuum and, therefore, far too complicated and unwieldy for easy visualization. The hue continuum (fig. 2.1) makes this readily apparent.

A more efficient representation of the full hue continuum would break the major hues down into fewer, memorable subsections that encapsulate the logic of the whole. One useful model is a simple graduated color wheel that shows the primary, secondary, and tertiary hues. Each hue is represented by a color that might reside at the center of its spectral zone (fig. 2.3).

A second, equally useful model is a six-pointed star composed of the primary and secondary triads (fig. 2.4).

2.2 Cobalt blue changes its temperature depending on its context.

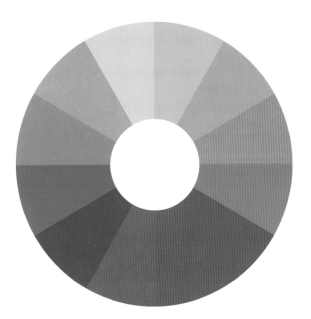

2.3 The hue continuum divided evenly into 12 hues.

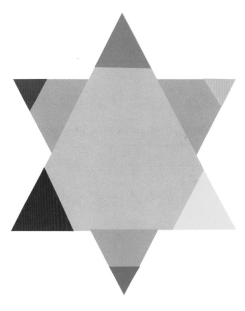

2.4 The primary and secondary triads configured as a star.

VALUE

Value signifies the relative lightness or darkness of a color. Another word for value is luminosity. In *Colour: A Text-Book of Modern Chromatics* (published in 1904) the color theorist Ogden Rood explains that the more light a color reflects, the more luminous it is said to be. A pure white piece of paper would, therefore, show maximum luminosity while a black piece of paper would have no luminosity at all. (In reality, there is no perfectly white or black paper; some light, albeit a small proportion, will be absorbed by even the whitest paper and some light reflected by even the blackest.)

The "pure" primary triad exhibits differing degrees of luminosity, yellow being the most luminous or lightest in value of the three. Blue and red are similar in value.

In figure 2.5, the three primaries are shown next to neutral squares that match their values but lack the qualities of hue and saturation.

2.5 The primary hues with matching gray values.

Visualizing the Value Continuum

As with the hue continuum, the VALUE CONTINUUM contains infinite variations (fig. 2.6). The full gamut of values is often simplified into a graduated scale called a GRAYSCALE. The grayscale shown below (fig. 2.7) consists of 11 steps ranging from black to white in even, progressive increments.

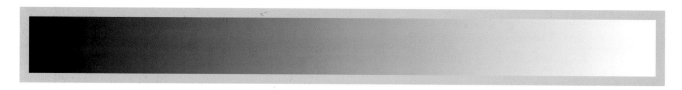

2.6 The value continuum.

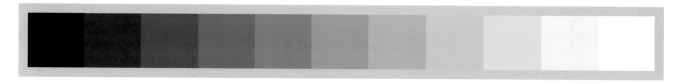

2.7 An 11-step grayscale.

An even simpler way to envision the value gamut is to break it down into three distinct categories: dark, medium, and light (fig. 2.8). The middle value should bisect the distance from the black to the white precisely.

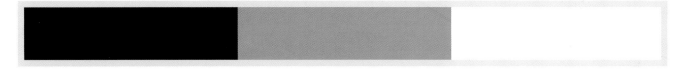

2.8 The value continuum evenly divided into three.

Black and white photography eliminates hue and saturation, leaving only value. Two versions of a painting by David Hockney are shown below (fig. 2.9). In the version on the right only the values of the colors are visible.

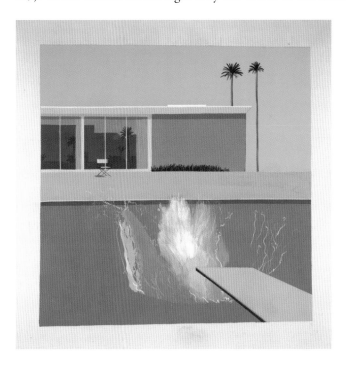 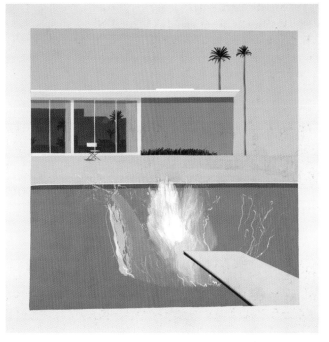

2.9 David Hockney, *A Bigger Splash*, 1967, acrylic on canvas, Tate, London. The image on the right shows only the values of the painting's colors.

SATURATION

Saturation refers to the relative purity of a color. The more a color resembles the clear, fully illuminated colors reflected in a prism, the more saturated it is said to be. In practice, it can be hard to identify saturation. The lighter of two colors is not necessarily the more saturated, as demonstrated below. In figure 2.10, the color that is lighter in value (a pale yellow) is *less* saturated than its green neighbor. In figure 2.11, the opposite is true: The lighter color (yellow) is also the *more* saturated of the pair.

2.10 The lighter color is less saturated.

2.11 The lighter color is more saturated.

It is sometimes difficult for the inexperienced colorist to distinguish saturation from value. To do so, one must learn to perceive the difference between the relative purity of a color and its lightness or darkness (value).

Figure 2.12 shows the three primary hues paired with neutral grays that are close in value to their partners.

2.12 All three primaries shown here are equally saturated, but yellow, being the lightest in value, is the most luminous.

Visualizing the Saturation Continuum

A SATURATION CONTINUUM that included all levels of saturation would be created by intermixing, in infinite degrees, any two fully saturated complementary hues (fig. 2.13).

2.13 The saturation continuum from orange to blue.

As with the hue and value continuums, the saturation continuum is too broad and undifferentiated to be useful in envisioning saturation in tandem with hue and value. To make it easier to think about the saturation gamut, we break it down into four distinct levels:

PRISMATIC COLORS are as pure in hue as is possible with pigments. Once a pure color has been altered through color mixing, it ceases to be prismatic (except when the admixture is a closely related hue, as when mixing yellow-orange into yellow).

Muted colors range from rich colors that lie just outside the prismatic zone, to the most saturated chromatic grays. One can create muted colors by adding black, white, or gray to a prismatic color. Adding the complement of a hue will also diminish its saturation and produce a muted color.

Chromatic grays exhibit a subtle, yet discernible hue. Except for the proportions involved, they are mixed in exactly the same manner as muted colors. Chromatic grays simply require larger quantities of black, white, gray, or the complement.

ACHROMATIC GRAYS compose the inner circle of the color wheel. Grays mixed from black and white are achromatic because, like black and white, they lack perceptible hue and saturation. Achromatic grays can also be produced by precisely intermixing two complementary colors so that each hue cancels the other out. Insofar as a gray registers the slightest amount of perceptible hue it should be considered a chromatic gray.

Two more useful terms are TINT and SHADE. A tint is a color lightened by adding white; a shade is a color darkened by adding black.

The saturation continuum seen below (fig. 2.14) shows the four levels of saturation in relation to the saturation continuum. On the continuum, prismatic color becomes muted color as soon as it loses the appearance of purity. Muted color, on the other hand, is transformed into chromatic gray gradually and imperceptibly. Chromatic gray becomes achromatic as soon as the slightest perceived presence of hue is extinguished.

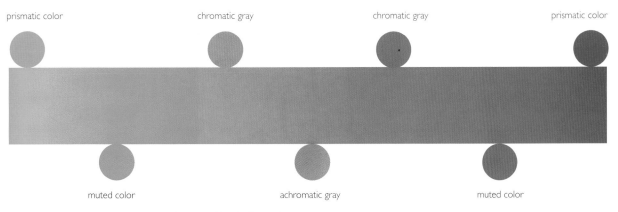

2.14 A saturation continuum showing the four named levels of saturation.

The distinction between muted color and chromatic gray is an important one. Each of these levels contains infinite tonalities and the line that divides them is somewhat ambiguous. Our first exercises will be aimed, in part, at establishing a clear idea of the location of that boundary. After a brief period of practice and discussion, the breaking point between the two categories becomes surprisingly clear. As with similar relative qualities in the arts, e.g. the difference between *piano* and *pianissimo* (quiet and very quiet) in music, the ambiguity that exists in the transition between muted color and chromatic gray in no way compromises the meaning or practicality of the terms. What is imperative is that you develop a precise sense of where muted color ends and chromatic gray begins and that you apply it consistently in your work.

At right, there are five examples of muted colors and, to the right of each one, is a chromatic gray version (fig. 2.15).

The Difference Between Luminosity and Inherent Light

As we have said, luminosity refers to value, or the relative lightness of a color. In reflected color, lightness and darkness are determined by the amount of light that is absorbed or reflected by surface molecules. White, yellow, and pink, for example, are highly reflective colors whereas violet and dark brown are absorbent. In color groups, clear contrast in value – even when the hue and saturation are similar – makes for clear delineation of the boundaries between shapes (fig. 2.16a).

The perception of INHERENT LIGHT in color is rooted in saturation. Unlike luminosity, it is immeasurable – more a psychological than physical event. It can best be described as an *inner glow* that a color seems to have in relation to other colors. One would expect that the more saturated a color is, the stronger its inherent light. But actually, the sensation depends on *relative* saturation and does not necessarily require prismatic color. For example, a muted color will seem to glow when seen among a group of duller colors. The effect also appears stronger when all the colors are close in value (fig. 2.16b).

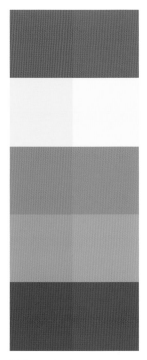

2.15 Muted colors and chromatic grays in the same hue.

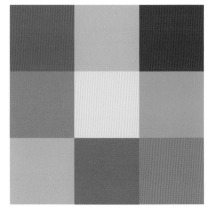

2.16a Value contrast defines shape boundaries.

2.16b Differences in saturation suggest varying amounts of inherent light.

The Hue/Saturation Color Wheel

The color wheel we use (fig. 2.17), shows divisions of both hue and saturation. Primary, secondary, and tertiary hues are arranged around the circle in even, pie-slice increments. The primary colors are subdivided into narrower co-primary slices.

In addition, variations of each hue representing the four levels of saturation are arranged in concentric circles. The outside ring shows the hues as prismatic colors. Directly inside that is a circle of muted colors. Inside that are chromatic grays. The innermost band is of an undivided achromatic gray.

This hue/saturation wheel maintains the value (relative lightness) of each prismatic color as it moves toward the center and loses saturation.

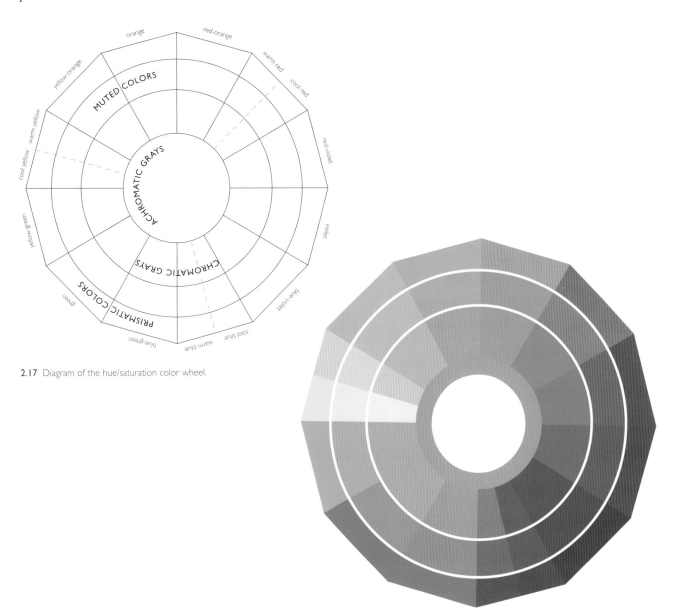

2.17 Diagram of the hue/saturation color wheel.

Traditional Color Schemes

Certain hue combinations have had standard, categorical names attached to them. They are based upon a fixed set of hue relationships, but may include all possible variations in value and saturation. The most common of these are: MONOCHROMATIC (one hue), ANALOGOUS (hues that lie adjacent to each other on the color wheel), complementary (two hues opposite each other on the color wheel), and TRIADIC (any three equidistant hues that form an equilateral triangle on the color wheel).

Traditionally, these color schemes helped simplify the problem of color harmony by providing an armature of pre-selected hue relationships upon which variations of related tones could be based.

Monochromatic

The painting by Mark Rothko shown below (fig. 2.18) is an example of a monochromatic color scheme. It is composed of a series of warm reds that range in saturation from a vivid, nearly prismatic red at the bottom, to the many subtle variations of red-brown that dominate the center. The values in the painting are all similarly dark.

The achromatic version of the painting, shown in figure 2.19, shows just how constrained in value it is. The most dramatic contrast is clearly not in hue or value, but in saturation.

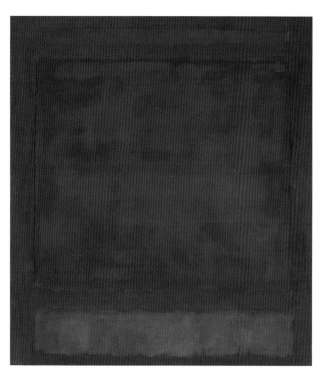 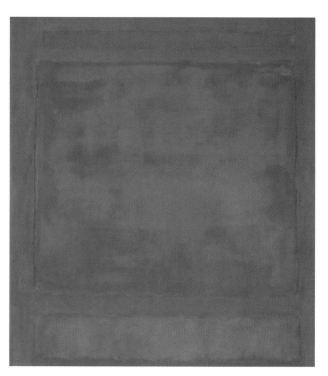

2.18 Mark Rothko, *No. 64*, 1960, oil on card. Collection of Kate Rothko Prizel.

2.19 An achromatic image of figure 2.18.

Analogous

Analogous colors reside adjacent to each other on the color wheel. Although there is no absolute parameter to the range of this category, analogous hues should go beyond one color but include only colors that share a hue. In the example at right (fig. 2.20), the central color is green and the hue range extends to blue-green on one side and yellow on the other. All the colors and tones share yellow as the common hue.

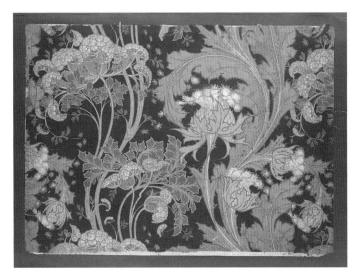

2.20 Silver Studio for G. P. & J. Baker, *Hemlock*, 1805, design for fabric. Victoria and Albert Museum, London. This is an analogous color scheme.

Complementary

Complementary color schemes are built around two hues that fall directly opposite each other on the color wheel. We should note that the complementary pairs on the color wheel are *approximately* complementary because each hue is itself an approximation of, or a guess at its ideal characteristic identity. Despite this approximation, complementary hue pairs have a special effect on each other. When intermixed, they produce a darker and duller color. In other words, both value and saturation are diminished through intermixing. But when they are placed next to each other, their contrast – the maximum possible contrast between two hues – generates visual energy and excitement.

The painting shown at right (fig. 2.21), is based on the complementary hues red and green. In this example, the liveliness of the complementary pair is supported by contrast in value and saturation.

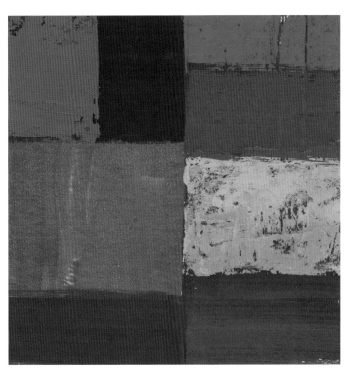

2.21 John Anderson, *Green and Red Study*. Private Collection. This is a complementary color scheme.

Triadic

Any three hues that lie equally spaced on the color wheel constitute a triad. The primary and secondary triads have names, but there are infinite, unnamable three-color combinations that involve the myriad hues that reside in between them. Although some hues are always excluded, triadic color schemes broadly represent the scope of the entire spectrum.

Because of its reputation as both irreducible and seminal to all other color, the primary triad has a mythic appeal for many artists. Early Modernists, especially those who had an interest in spiritualism, e.g. Mondrian and Kandinsky, assigned metaphysical significance to red, yellow, and blue.

Nancy Crow's quilt (fig. 2.22) demonstrates a dramatic use of the primary triad. Notice the subtle hue shifts in the yellows and blues. Along with the bright primaries, the artist has employed black and a warm, dark gray which isolate smaller groupings of the primary hues and soften the effect of their contrast.

2.22 Nancy Crow, *Looking for a Reprieve*, 1993–94, pieced and quilted cotton fabrics hand-dyed by the artist. Courtesy of the Artist.

Color Range

Another way to look at color combinations is through the lens of color range, i.e. the distribution of color in relation to its full potential for contrast. We can discuss color range in terms of hue, value, and saturation using the terms "broad," "moderate," or "narrow" for all three range categories. For example, in the row of four colors at right (fig. 2.23), we see a broad range of hues because the primary triad is present and the addition of violet makes a complementary pair with yellow ocher. It is a broad hue range because the hues shown here encompass the color wheel. (Complementary and triadic color schemes, in particular, have broad hue ranges.)

2.23 A broad hue range, broad value range, and broad saturation range.

Looking at the value structure of this color sequence, we see a very light color (pink), a very dark color (violet), and two middle tones (blue and ocher). These encompass the value scale and therefore constitute a broad value range.

The saturation range of this sequence is also broad: It contains a prismatic color (violet), a muted color (blue), and two chromatic grays (yellow ocher and pink).

In the next sequence (fig. 2.24), the analogous hue range is narrow. (Analogous and monochromatic color schemes, by definition, have narrow hue ranges.) The value range, by contrast, is broad because the red is quite dark and the yellow on the left approaches the lightest end of the value scale. The orange is close to a mid-tone. Once again the entire value scale is almost fully represented.

2.24 A narrow hue range, broad value range, and moderate saturation range.

The saturation range of this sequence is moderate because among these four colors there are two prismatic yellows and two muted colors.

In the final example (fig. 2.25), the colors are tightly knit. The hue range is narrow: monochromatic. The value range is narrow because all four colors hover around the middle of the value scale. And all four colors are at the same saturation level – on the cusp between muted color and chromatic gray.

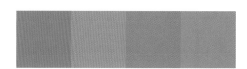

2.25 A narrow hue range, narrow value range, and narrow range of saturation.

Discussing Color Range

Because describing what we see concentrates our attention, the discussion of color range in works of art and design can be revealing. In Brian Cronin's illustration (fig. 2.26), we see a narrow hue range of red to yellow and a broad value range which includes the polar extremes of black and white. The range of saturation is narrow, all colors are constrained to chromatic gray, and the overall effect is of a quiet, stylized naturalism.

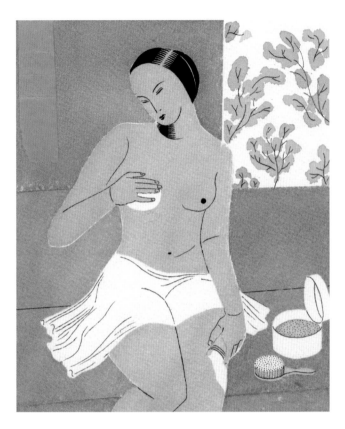

2.26 Brian Cronin, *Untitled*, 1992, India ink and acrylic on watercolor paper. Courtesy of the Artist.

Patrick Cauley's painting (fig. 2.27) is predominately yellow with blue and green accents. Its hue range is moderate, stretching from yellow to blue. The values are broadly represented, from dark, jewel-like greens to a light, creamy yellow. Every level of saturation appears in the painting, from a prismatic blue and green to subtle chromatic grays.

2.27 Patick Cauley, *Untitled*, 2005, acrylic and oil on panel. Courtesy of the Artist.

Manipulating Hue, Value, and Saturation Independently

Hue, value, and saturation are discrete color factors and can be manipulated independently. Sometimes the adjustment of one factor is called for without disturbing the others. Color can be altered through color mixing or by controlling the color's context through color positioning.

Color Mixing

A shift in value might be desired without any change in hue or saturation. Two squares within the gray rectangle at right (fig. 2.28) show a color shift from left to right. The tinted square on the right is altered only in value; hue and saturation remain the same (it remains green and a muted color).

In figure 2.29, a green square on the left is altered to create a new square on the right, but here the shift is in saturation only; hue and value remain the same.

In the third example (fig. 2.30), the green square on the left is altered only in hue – it shifts to blue – while remaining prismatic and at the same value.

Color Positioning

Because of an optical phenomenon, colors can appear to change according to their surroundings (you can read more about this in Part Five).

In both examples shown below, all four of the center squares are actually identical greens. Their altered appearances are due to changes in the surrounding colors.

In figure 2.31, the value of the green center square appears to shift when seen against the lighter square to its right. Hue and saturation remain the same.

In figure 2.32, the value and saturation remain constant, but the green square appears more blue against the yellow-green background.

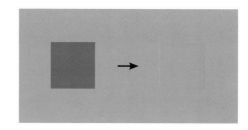

2.28 A shift only in value.

2.29 A shift only in saturation.

2.30 A shift only in hue.

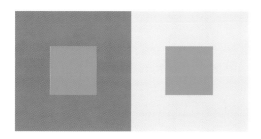

2.31 The center green square appears to shift in value.

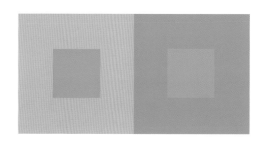

2.32 The same green appears to shift in hue.

Inherent Limitations to the Independence of Color Factors

The independence of color factors is limited in certain circumstances. For example, when fully saturated, yellows are always light in value. Furthermore, the value of any prismatic yellow can only be raised a little by adding white before its saturation starts to diminish appreciably. (This is compounded by the fact that yellow pigments tend to be weak and are easily overpowered by admixtures of more concentrated pigments.)

Violet, yellow's complement, is similarly constrained by its native value. In its prismatic state, violet is the darkest hue. Beginning so dark makes the creation of darker violet muted colors and chromatic grays somewhat limited in possibility. Compared to mid-value hues, e.g. orange and green, yellow and violet present a special challenge in color mixing.

Describing a Color

Here is a little classroom game to test both the understanding of basic terminology and mixing skill:

A student receives a small patch of painted paper containing one color. Without showing it to anyone, she or he describes the color using only the terminology introduced in this chapter; no other references are allowed. Guided by that description, another student attempts to mix the color. The result is then compared with the original.

Some sample descriptions:

Figure 2.34 – Hue: cool red / Value: middle value / Saturation: muted color.

Figure 2.35 – Hue: green / Value: dark, but not black / Saturation: chromatic gray.

Figure 2.36 – Hue: warm yellow / Value: middle light / Saturation: chromatic gray.

(A grayscale can be used to provide a more precise description of the value, e.g. "value #8" instead of "middle light.")

2.34 2.35 2.36

Using words to describe what we see rivets our attention to visual phenomena in a way that casual looking seldom does. Of course, it is impossible to describe any color with absolute precision, but by focusing on contrasts of hue, value, and saturation we can discuss color with some clarity.

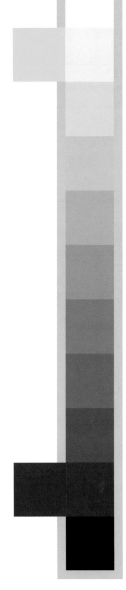

2.33 A comparison of prismatic yellow and violet to their value equivalents on the grayscale.

Color Proportion

Color proportion may be thought of in terms of hue, value, and saturation. In the three squares shown below (fig. 2.37), the range of all three factors is broad. When all factors are broadly dispersed, proportional variations create a dramatic difference in visual effect. If, when looking at this example, you isolate each one by masking the others with a piece of paper, you can see just how distinctive each variation is. The manipulation of color proportion is especially useful in the textile industry, where a limited number of colors are often ingeniously exploited.

2.37 Three proportional variations of three colors with diversity in hue, value, and saturation.

The second set of examples (fig. 2.38), consists of three closely related colors. All are green, all are in the low-middle value range, and all are muted colors. As you can see, with minimal contrast in all three color factors, the effect of proportional variation is much less powerful.

2.38 Three proportional variations of three closely related colors.

3. MATERIALS AND TECHNIQUES

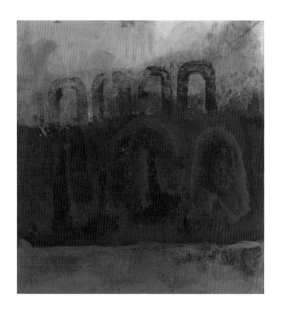

"And how important it is to know how to mix on the palette those colors which have no name and yet are the real foundation of everything."

Vincent van Gogh

WORKSHOP MATERIALS LIST

These are the materials you will need for this course of study:

1. Card stock: sold in packages of 250 sheets at most stationery stores. It comes letter-size (11 x 8 1/2 inches or 27.9 x 21.6 cm). This smooth white card is heavy enough to paint on and also makes a sturdy support for glued elements. A more expensive alternative is two-ply vellum Bristol Board.

2. Thin paper for collage color swatches: Bienfang "Graphics 360" tablet. This 100% rag paper is very thin and strong. A less costly alternative would be common newsprint.

3. Water container and paper towels.

4. Brush #1: a 1-inch (2.54-cm) flat aquarelle brush with a beveled clear handle for burnishing.

5. Brush #2: a small round sable brush. Less costly: a synthetic or natural/synthetic blend.

6. Palette knife.

7. Permanent glue stick.

8. Two small plastic jars (2–4 ounces), for storing pre-mixed "darks."

9. Scissors and a utility knife.

10. Pencil.

11. Ruler.

12. Roll of Scotch brand removable magic tape (3M item #811) for masking.

13. Palette: If using traditional gouache, you need a plastic cup palette. The most useful have six or more wells and a flat area for color mixing. If using acrylic gouache: paper palette pad. Less expensive: paper plate.

14. Portfolio or box: to contain both finished work and work in progress. There are several inexpensive archival "book-style" portfolios on the market whose pages can accommodate standard-size card stock. They not only store work, but can also hold color swatches for use in color studies.

PAINT

The most critical material for this class is the paint. The color principles we will be exploring apply to all kinds of paint, but the studies are most efficiently made with fast-drying, water-based paints that dry to a matte finish. Drying speed allows for instant correction and the matte surface provides a clear view of the color from any angle.

Gouache

Traditionally, i.e. before computers, the design industry favored a water-based paint called "gouache." Gouache can be used somewhat like watercolor, but it can also be extremely opaque and produce lucid, flat tones in almost any color. Its highly readable surface makes even the subtlest tones clearly evident.

Gouache is manufactured by many well-known paint companies at varying levels of quality. The best brands are opaque and highly pigmented. The poorer brands tend to be more translucent and weak as an admixture. Each company has its own color naming system, and even when the colors have the same names, they can vary in appearance from manufacturer to manufacturer.

Compared to acrylic paint, gouache requires more patience in handling, especially if you are trying to achieve flat, evenly opaque tones. Unlike acrylic paint, the dried gouache paint film can be reactivated with water. Therefore, subsequent applications may intermingle with underpainted color. Freshly dried gouache is more reworkable than paint that has dried overnight, and vigorous brushing will disturb an underlying color more dramatically than will a quick, light application. This may be a disadvantage of the medium for the beginner, but after a little practice control comes more easily.

Acrylic Gouache

Acrylic paint is usually too translucent to be ideal for our color studies, but several paint manufacturers make a hybrid that combines the best qualities of gouache and acrylic. It is usually marketed under the name "acrylic gouache," "matte acrylic," or some variant thereof. While no acrylic gouache can match the refinement of a high-quality gouache paint, the best come close. And they do have one great advantage over gouache: They dry to an unreworkable state, so any number of corrections and cover-ups are easy to make.

Either gouache or acrylic gouache will work well in color studies. There are several fine brands on the market, but we're recommending five: three gouaches and two acrylic gouaches. Acrylic gouache is less expensive than traditional gouache, but the color doesn't go quite as far. In general, it is easier to find the colors you need at an online art supply distributor than in a retail art supply store.

Color List and Five Recommended Paints

The colors you will need for this course match the six co-primary colors introduced in Part One. The list includes warm and cool versions of the primary triad plus a red, yellow, and blue earth tone. You will also need white (which should be purchased in a larger tube size) and a dark brown.

As examples we list the following five paints: Winsor & Newton Designers' Gouache, Holbein Artists' Gouache, Daler-Rowney Designers' Gouache, Turner Acryl Gouache, and Jo Sonja's Artists Colors. Winsor & Newton, Holbein, and Daler-Rowney all make fine traditional gouache and sell their paint in 14 or 15 ml tubes. Turner's Acryl Gouache is a high-quality paint that comes in 20 and 100 ml tubes. Jo Sonja's Artists' Colors is a more affordable acrylic gouache developed for decorative painting and comes in 75 ml tubes.

Stacked below are the six co-primaries, the earth-tone triad, and recommended matching colors and paint.

cool red	Winsor & Newton: Alizarin Crimson Holbein: Carmine Daler-Rowney: Crimson Turner: Carmine Jo Sonja: Napthol Crimson	red earth tone	Winsor & Newton: Red Ochre Holbein: Burnt Sienna Daler-Rowney: Burnt Sienna Turner: Burnt Sienna Jo Sonja: Burnt Sienna
warm red	Winsor & Newton: Flame Red Holbein: Flame Red Daler-Rowney: Vermilion Red Turner: Permanent Scarlet Jo Sonja: Cadmium Scarlet	yellow earth tone	Winsor & Newton: Yellow Ochre Holbein: Yellow Ochre Daler-Rowney: Yellow Ochre Turner: Yellow Ochre Jo Sonja: Yellow Oxide
cool yellow	Winsor & Newton: Lemon Yellow Holbein: Lemon Yellow Daler-Rowney: Canary Turner: Permanent Yellow Jo Sonja: Yellow Light	blue eartj tone	Winsor & Newton: Indigo Holbein: Ash Blue Daler-Rowney: Payne's Gray Turner: Grayish Blue Jo Sonja: Payne's Gray
warm yellow	Winsor & Newton: Permanent Yellow Deep Holbein: Permanent Yellow Deep Daler-Rowney: Indian Yellow Turner: Permanent Yellow Deep Jo Sonja: Yellow Deep	white	Winsor & Newton: Permanent White Holbein: Permanent White Daler-Rowney: Permanent White Turner: White Jo Sonja: Permanent White (Note: Zinc White is too transparent for our purposes.)
cool blue	Winsor & Newton: Ultramarine Blue Holbein: Ultramarine Blue Daler-Rowney: Ultramarine Blue Turner: Ultramarine Blue Jo Sonja: Ultramarine Blue Deep	dark brown	Winsor & Newton: Sepia Holbein: Burnt Umber Daler-Rowney: Burnt Umber Turner: Sepia Jo Sonja: Burnt Umber
warm blue	Winsor & Newton: Ultramarine Green Shade Holbein: Turquoise Blue Daler-Rowney: Cerulean Hue Turner: Sky Blue Jo Sonja: Pthalo Blue		

Brands can also be intermingled, but be prepared for slight differences in handling. And, although it is technically sound to mix traditional gouache with acrylic-based gouaches, it would be preferable to choose one or other technology and work consistently with it.

GUIDELINES AND SUGGESTIONS FOR MAKING COLOR STUDIES

The heart of this book is a sequence of color studies that organizes the exploration of color principles and provides direct physical experience of them. The studies are carefully designed to isolate visual aspects of color while building understanding as you progress through the series of assignments.

Unlike many color courses that rely upon "found" color, e.g. color cut from magazines or packaged color samples, this approach relies primarily upon "building color" through color mixing. Precise color mixing offers both a greater range of tones and more control than found color can provide. Even more important is the benefit gained by the integration of thought and action that occurs each time a color is mixed on the palette. Color mixing brings you inside the color. You gain a "physical understanding" that helps you transform conscious analysis into a more relaxed relationship to color.

For some, the prospect of color mixing can be intimidating – especially for those not confident with drawing and painting or those who might normally work in other media. But, in fact, this is not a painting course and demands only modest painting skills.

These studies emphasize a particular color lesson and not perfect craftsmanship. The rule of thumb is to work within your ability. If you have difficulty with direct painting, build your studies from cut or torn paper. If you have trouble painting razor-sharp straight edges, adopt a more painterly approach. Poor craft is only a problem when sloppy execution obscures the intent of a study, and it takes but a little care to avoid that.

General Design Guidelines

There has always been some debate about the design of color studies. Some instructors maintain that the design format should be constant and based upon simple geometric shapes. They believe that color studies should focus exclusively on color relationships and that formal variations of any kind are a distraction.

Other instructors hold that complete freedom of design is more interesting for the student and more akin to normal studio practice. Indeed, one persistent general criticism of color theory courses has been that color revelations experienced in the lab tend to stay there and that students have difficulty connecting those discoveries to their own work.

In this course we try to strike a balance between those opposing views. You should feel free to experiment with formats that interest you. But, above all, do not lose sight of the goal of all of these studies: to clearly and concisely demonstrate the color principle at hand.

Technical Tips for Making Color Studies

Design Tips

First and foremost, keep your designs simple. It is easy and even tempting to get sidetracked by an overly intricate design. Remember that color adds its own complexity. Your goal should be to make designs that demonstrate the color principle at hand as clearly and eloquently as possible. As a rule, try to spend no more than two hours on any one study. That way, you will be apt to avoid unnecessarily complicated designs.

Try to make your designs flat; avoid blending the paint as you would in a traditional oil painting. Both gouache and acrylic gouache are fast-drying, water-based paints that resist blending. The speed of drying encourages clean color mixtures and distinct color shapes for a more graphic read.

Find a way of painting that suits your interest and ability. Many of the assignments can be done with painted paper collage. Assignments can also be interpreted in either a painterly or hard-edged painting style. Removable tape facilitates sharp-edged painting. (Other techniques will be discussed in the section on "free studies" in Part Four.)

Designing in Groups

When making a group of studies, try to maintain a consistent format and mode of painting. Design configurations should be either identical throughout a multi-part color assignment (as shown in the two studies in fig. 3.1), or closely related permutations on a structural theme (fig. 3.2). Too much variation within a group of color studies can make it difficult to assess the effect of color relationships from one study to another.

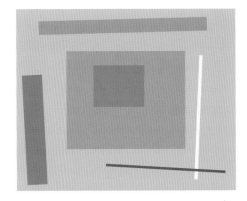

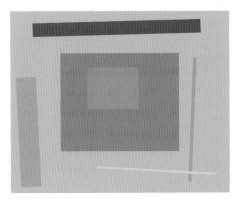

3.1 Two identical designs with color variations. When the format is repeated, the role of the color relationships is very clear.

3.2 Three closely related designs with color variations. Each image bears a "family resemblance" to the others in the series.

Painting Swatches

All the studies in this course should be relatively small, usually not exceeding 48 square inches (310 square cm). Typical proportions are 5 x 7 or 6 x 6 inches (12.7 x 17.7 or 15.2 x 15.2 cm); small enough to be mounted on a letter- sized sheet of card stock. The small dimensions make it possible to create many studies in a short time and organize them into a book-style portfolio for later reference.

Torn or cut painted paper collage is a good technique for many of these assignments, particularly for those who have little confidence in their painting skills. Collage paper should be thin, adhered to the prepainted background with a permanent glue stick and burnished down on the card stock with the beveled handle of a brush or something similar. When burnishing, protect the fragile paint surface by placing a sheet of paper over the design and pressing down on that rather than directly on the paint surface.

Because the studies are small, color swatches that you create for collage need only be about 5 x 5 inches (12.7 x 12.7 cm) (fig. 3.3). Leftover painted swatches should be saved and organized for later use. Any wet paint at the end of a session should be painted out on newsprint in swatches and preserved. Swatches can be stored in envelopes or in the transparent pages of your portfolio book.

Establishing a Background Color

Most technical approaches, including collage, begin with a colored background painted directly on card stock using removable tape to establish the boundaries of the square or rectangle (fig. 3.4). The painted background is visible in the finished study (fig. 3.5) and eliminates the white of the page.

Using Traditional Gouache

Traditional gouache takes a little getting used to. It is akin to watercolor and can be used thinly in washes or, unlike watercolor, with a dense opacity. In these studies you will often want to paint clean flat shapes of unbroken color. To do this, put your colors out in the little cups that line the edge of your palette. Mix into each color enough water to bring it to the consistency of whole milk. It is important that you get the colors well mixed before applying them to avoid streaking in the paint film.

As you brush the paint out it will begin to dry immediately. Do not keep brushing over painted areas in an attempt to keep the surface "even" in appearance. Except for the darkest tones, colors tend to darken as they dry and can appear quite streaky when doing so. Ignore that. When the paint film is totally dry, it will even out.

Finally, clean your brush between each color (and keep the water clean). After each cleaning, gently squeeze the clean water from the brush hairs.

3.3 Color swatches are painted on newsprint for use in collage technique. Any surface buckling of the paper can be flattened under the weight of several books after the swatches are cut out of the page. A razor blade is shown for size reference.

3.4 Background color with tape mask removed from two sides to reveal sharp outer edge.

3.5 Color study using backgound color shown directly above.

Mixing a Warm and Cool Dark

In the list of colors recommended for this course there is no black. Black is omitted because it has such a small amount of perceptible chromatic content. Black pigments differ in temperature, but these differences are too subtle for our purposes. Having two distinct darks, one warm and one cool, enlivens color mixing and imparts a sense of inherent light to a tone where black tends to extinguish it.

Before beginning the studies in the next chapter, you will need to mix two small containers of CHROMATIC DARKS (dark chromatic grays) that are almost black in value but are clearly either warm or cool in temperature.

Make these two chromatic darks by mixing the cool blue and the dark brown recommended on page 41 for your paint brand. In the resulting dark tones, the warm dark will be browner in appearance and the cool, bluer. These stock mixtures will serve as readymade dark tones for color mixing and can be used as one method to produce muted colors and chromatic grays.

When testing your dark mixtures for temperature, paint each one out as a circle and mix each with white to create a mid-value version (fig. 3.6). Bear in mind that white is much weaker than either the blue or brown in admixture, therefore it takes more white to make a midtone. This is true of color mixing in general. When mixing weak pigments with strong ones, the weak pigment must be used in a larger quantity to create what looks like a 50–50 mix.

Mix enough of the two chromatic darks for about 40 studies, approximately 1–2 ounces of each. Store them in the small plastic containers mentioned in the materials list at the start of this chapter. It is important that the containers have tight lids. (Tip: Storing your dark mixtures in a refrigerator between painting sessions will keep them from drying out.)

Making a Grayscale

In the course of these studies an accurate grayscale is a valuable aid to color mixing and selection (fig. 3.7). It should be achromatic (having no hue bias) and consist of 11 even steps from extremely dark to white. A grayscale is easy to make in either Adobe Photoshop or Illustrator. Print it on heavy paper or glue it to card stock. Cut the grayscale out so that it can be set down directly against other colors for comparison.

If you have no access to this computer software, carefully paint a grayscale using a mixture of your two chromatic darks to create a neutral, achromatic "black." Remember, because the dark color is so much stronger than the white, you will need very little of the dark admixture in most of these values. You can paint the grayscale directly on card stock using removable masking tape (Scotch brand tape #811), or make small swatches on newsprint and glue them in sequence on card stock with a glue stick.

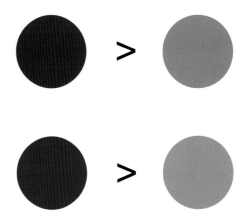

3.6 Adding white to each mixture clearly reveals its temperature bias.

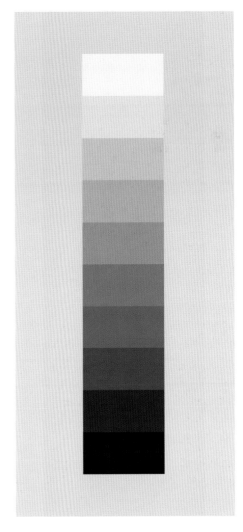

3.7 A digitally generated grayscale. Print yours at around 9 inches (22.9 cm) high and cut it from the page so that it can be placed next to colors for close visual comparison.

4. BEGINNING COLOR STUDIES

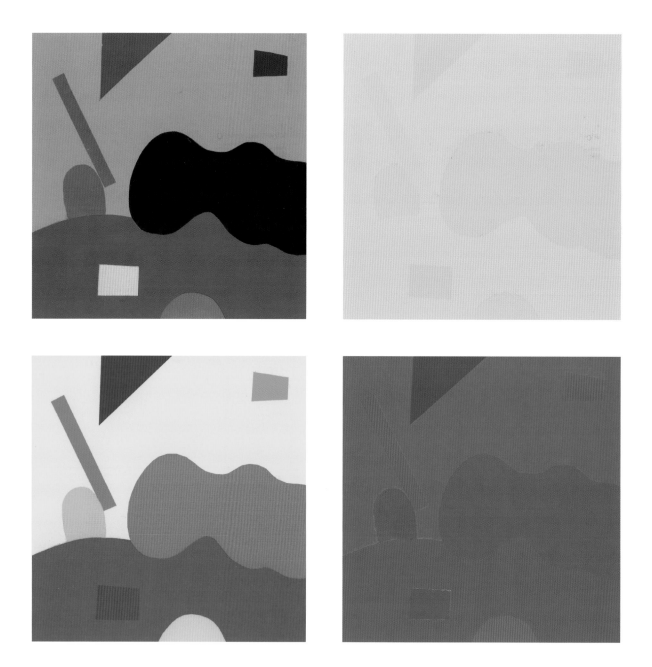

"I've handled color as a man should behave. You may conclude that I consider ethics and aesthetics as one."

Josef Albers

THE COLOR WORKSHOP

This book is meant to function as a "workshop" in which one reads about color principles and then explores them through a sequence of small color studies. These studies are designed to fortify the text with a direct physical experience of color structure and interrelationships, and their effect on the eye and mind. While the book can simply be read as a general guide to color, its value will be most fully realized by those who take the time to do the color assignments.

Assignments are presented in tandem with the introduction of color principles and are meant to be done in the sequence in which they are offered. They were developed and tested over a 12-year period at the Rhode Island School of Design with graphic designers, painters, textile designers, illustrators, and weavers. While there are certainly other effective color exercises, these have been tuned specifically to this course of study.

Reading the text and then making the studies results in an ensemble of little paintings and/or collages that can be kept as a reference to revisit later. They can also be augmented with continuing "free studies," the self-directed color experiments that follow most assignments.

Completing the Course

The course of study represented in this book is broken up into six sections. Each section examines fundamental color principles from a different, yet interrelated angle and provides assignments that test and strengthen understanding. Each assignment is preceded by a brief explanation of its pedagogical intent in the form of a "rationale."

The six sections are: Beginning Color Studies, Color Interaction, Applying Color Principles, Color Harmony, Color Research, and Color Experience and Interpretation. A seventh section, Color Studies on the Computer, offers guidelines for doing most of the assignments in Adobe Illustrator.

The lessons presented in this workshop can be easily accomplished in around 15 weeks if you spend approximately six to eight hours a week working on the assignments. Ideally, you will be able to follow the sequence and complete them all. If your time is limited, however, select those assignments that relate most directly to your area of interest. Using common sense, you can assess the relative value of each section for your needs.

The first five assignments (Parts Four and Five) deal with the structure of color and are indispensable. They provide the conceptual foundation to all that follows.

NAMING COLORS

The way we commonly describe a color tells us a lot about how we unconsciously rank hue, value, and saturation. In normal parlance, we tend to give priority to hue, accord secondary recognition to value, and integrate saturation, if at all, as a third consideration.

When we are asked to describe the color of an object, the first quality that comes to mind is its hue, e.g. a *red* barn, *blue* sky, etc. The sentence "Mary is wearing a red sweater" tends to conjure up the mental image of a generic red, usually a "pure" red. It may be a red of any temperature, e.g. crimson (cool) or scarlet (warm), but the imagined color will likely be a highly saturated if not prismatic red (fig. 4.1).

If the same description included a value reference, e.g. "Mary is wearing a medium-light red sweater," it would tell us more, letting us know both the hue and the approximate value of the color. It is not too uncommon for a verbal description to refer to both hue and value, and it is not difficult for most people to summon up both color qualities simultaneously in the mind to imagine something like the color at right (fig. 4.2).

By adding a reference to the color's saturation, we can raise an even more complete picture of the color in our minds. The statement "Mary is wearing a medium-light and dull red sweater," tells us that the red in question is not the vivid red of a fire engine or even a rich tint of red. It is, in fact, the more subdued color of a faded canvas bookcover (fig. 4.3). The addition of saturation to the description locates the color more precisely.

This third type of description, one that includes all three structural qualities, is rare. It is relatively easy to hold value and hue in the mind simultaneously; sort of like juggling two balls in the air. But conceiving of all three qualities at the same time, like adding a third ball, is much more difficult, at least at first. To make things trickier still, value appears to be more discernible than saturation, especially in lighter colors. There also is a tendency to confuse value with saturation, when the two qualities are, in fact, different.

Unlike the conscious mind, which is influenced by memory and habit, the eye sees all three aspects of color simultaneously. Training the mind to acknowledge what the eye sees is the key that unlocks color understanding.

4.1 A red sweater.

4.2 A medium-light red sweater.

4.3 A medium-light and dull red sweater.

COMMERCIAL COLOR NAMES

Precise color nomenclature is needed in the area of cosmetics, fabrics, and, especially, interior and exterior house paints. Thousands of tints and shades are given individual names so that colors can be mixed uniformly over time. Names range from those based upon well-known objects, e.g. "Clover Green" or "Lime," to more fanciful interpretations like "Wales Green" or "Early Spring."

Commercial color names try to encompass the totality of a color through analogy but, while extremely useful in the context of the hardware or department store, are of little value to an artist or designer.

MUNCELL'S COLOR NOTATION

In 1905, an American painter named Albert H. Muncell published *A Color Notation*. Muncell was dissatisfied with color names, which he regarded as unreliable and "foolish," and so devised a system of nomenclature based on hue, value, and saturation (which he called "chroma"). He broke the color wheel down into five principal hues and five intermediate hues, making a total of ten. The hues are divided even further into ten numbered subsets. A specific violet, for example, might be centered at "5" or shift by degrees toward a neighboring hue on either side, with "2.5" leaning toward blue-violet and "7.5" toward red-violet.

Each hue is linked to ten values and 14 levels of saturation. Colors are identified by a composite number that refers to all three color dimensions, hue, value, and chroma (saturation). For example, a somewhat saturated, centered blue of medium lightness would have the designation "5B 5/8." The 5B indicates a temperature-neutral blue, one dead center in the blue zone. The second "5" indicates the middle point on the value scale of ten values. The "8" refers to the color's saturation; it is a muted color (fig. 4.4).

Muncell's notation is still considered the most practical attempt at a system of color nomenclature. While we will not be using the Muncell numbering system explicitly, we will be examining colors and color combinations with their hue, value, and saturation content in mind.

A final word on the subject of color naming: The color names most germane to our enterprise are those of the pigments and dyes they are made from. Pigments usually carry names that are rooted in their chemical sources, e.g. "Yellow Ocher," "Alizarin Crimson," or "Pthalocyanine Blue." The colors we mix from them invariably go unnamed.

When it comes to understanding color, the names of specific colors are of little importance. What matters far more is our conception of how colors are constructed and how they behave in relation to each other.

4.4 A blue that would be designated 5B 5/8 in Muncell's notation.

RATIONALE FOR ASSIGNMENTS ONE TO FOUR

The first four assignments are designed to clarify the structure of color. Inverting the natural tendency to put hue first, these studies examine hue and value through the lens of saturation. They begin with the most subtle colors, chromatic grays, and work toward the most saturated: prismatic colors.

These studies go far beyond the definitions, however. They also reveal ways in which hue, value, and saturation are both independent and interdependent in color mixing and in combination with each other. Most importantly, they demonstrate the visual effect of imposed restrictions in any or all three of the structural factors.

ASSIGNMENT 1: *Chromatic Gray Studies*

1A. Make a small painted-paper collage using six to nine shapes not including the background color. Prepare for the assignment by painting a page of chromatic gray swatches in a broad range of values and hues (see "Painting Swatches" on page 44 and fig. 4.5). All the colors in this study must fall in the chromatic gray saturation range. The value range should be broad, including values drawn from all over the value continuum. There should also be broad hue representation (colors that come from across the color spectrum). Use no color more than once.

As shown in Part Three, create one format and repeat it throughout the first four assignments with color variations, or make variations of a design, altering it slightly each time. The important thing is to maintain a stylistic consistency so the focus remains on color. Remember to keep your design simple: Its purpose is to clearly demonstrate the color principle at hand.

Example:
Figure 4.6 at right has nine shapes (including the background color). All the colors are chromatic gray and the value range is broad. The darkest color is the large, dark, blue-back shape on the right, and the lightest is the pale-yellow rectangle at bottom left. The hue range – which includes yellow, green, and violet – is also broad.

1B. Make a second study in chromatic grays. This time constrain the values to one part of the value range. Use your grayscale to match the values of the colors you are creating. All the values should be confined to one or two adjacent sections of the grayscale. Maintain a broad hue range.

Example:
Figure 4.7 uses the same design format as in Assignment 1A. The values are constrained to the middle section of the grayscale. The hues, like those in figure 4.6, are broadly represented and include yellow, violet, and green.

When colors are close in value, it is difficult to distinguish one shape from another. The overall effect is much quieter than with a broader value range. Combining close value relationships with low saturation makes for an extremely subtle coloristic experience.

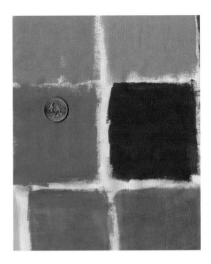

4.5 Chromatic gray color swatches with a U.S. 25-cent piece for scale reference.

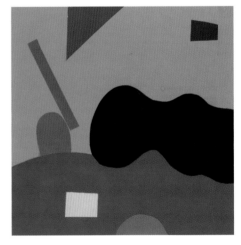

4.6 Chromatic grays, broad value range, broad hue range.

4.7 Chromatic grays, narrow value range, broad hue range.

MIXING CHROMATIC GRAYS AND MUTED COLORS

There are several ways to mix chromatic grays and muted colors from a highly saturated color right out of the tube: (1) add white, (2) add black, (3) add its complement, (4) add chromatic gray, or (5) add achromatic gray. With admixtures of black, white, or gray, the more you add, the more you diminish the saturation of the original color.

Using green as an example (fig. 4.8), the addition of a moderate amount of gray of the same value will bring the original vivid green into the category of muted color. Adding more gray will bring the saturation down to the chromatic gray level (fig. 4.9). (The percentages shown in the illustrations are merely meant to indicate relative proportions, not to be taken literally.)

Because the gray admixtures in these examples are of the same value as the original green, the value of the resulting tone will be the same as that of the original color. If you add a darker or lighter gray, the value of the result will deviate from that of the original color accordingly.

Complementary admixtures behave differently. For example, adding red to green will diminish its saturation, but the result will also be darker in value.

4.8 The green on the left mixed with 30% of its quantity of gray results in a muted color.

4.9 The same green mixed with a larger quantity of the same gray results in a chromatic gray.

ON THE SUBTLETY OF CHROMATIC GRAY

When an entire image is limited in value and saturation, our minds tend to compensate for those limitations. An excellent example of this can be seen at right. Giorgio Morandi concentrated primarily on still-life painting throughout his career. His palette is typically subdued, consisting mostly of chromatic grays with an occasional touch of muted color. But he orchestrated his grays to maximize their temperature contrast and made the most of what subtle hues he allowed himself.

In figure 4.10, Morandi makes effective use of minimal value and saturation contrast. The "dark" stripes on the "white" pitcher create a visual accent, as does the "orange" canister to its right.

In the detail of Morandi's painting (fig. 4.11), several circular shapes are superimposed to isolate specific color areas for easy comparison. The black circle that isolates the darkest color in the painting reveals it to be a mid-tone at value five. Similarly, when the lightest tone in the painting is seen against a pure white circle, it turns out to be a value seven, only a few steps lighter than the darkest color. The orange tone is particularly interesting. It is the richest color in the painting, but against a prismatic orange ellipse it appears to be a chromatic gray.

4.10 Giorgio Morandi, *Still Life*, 1949, oil on canvas. Museo Morandi, Bologna.

4.11 Detail of figure 4.10.

ASSIGNMENT 2: *Muted Color Studies*

2A. Make a small painted-paper collage using six to nine shapes not including the background color. As with Assignment 1, prepare by painting a page of muted color swatches in a broad range of values and hues. All the colors in this study must fall in the muted color saturation range. The value range should be broad, including values drawn from all over the value scale, and there should be broad hue representation (colors that come from locations across the color spectrum). Use no color more than once.

As outlined in Part Three, continue with the format you used in Assignment 1, or continue making variations of a design, altering it slightly each time. The important thing is to maintain a stylistic consistency so the focus will be on color.

Example:
Figure 4.12 uses the same format as in Assignments 1A and B. All the colors are muted colors. The value and hue ranges are broad.

2B. Make a second study in muted colors. As in 1B, constrain the values to one part of the value range. Again, use your grayscale to match the values of the colors you are creating. All the colors should match one or, at most, two adjacent sections of the grayscale. Maintain a broad hue range.

Example:
Figure 4.13 conforms to the specifications of the assignment. All colors in this study are muted colors, the hue range is broad, and all the values are very close to each other – within the third block of an 11-step grayscale.

When two colors are close in value and saturation, the boundary between them is difficult to distinguish. This is most true, however, when the hues are adjacent to each other on the spectrum, as shown below (fig. 4.14).

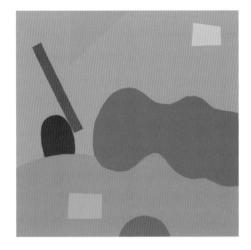

4.12 Muted colors, broad value range, broad hue range.

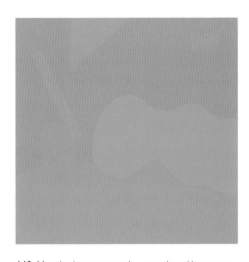

4.13 Muted colors, narrow value range, broad hue range.

4.14 Two adjacent hues that are close in value.

When the hues are disparate, especially when they are complements or near complements, the hue (and temperature) disparity asserts their boundary. Even though the colors below (fig. 4.15) are close in saturation and value, the line between them is more readable than when the hues are closely related.

4.15 Two complementary hues that are close in value and saturation.

COLOR KEYS

Saying that a group of colors are KEYED means that they are tightly unified in one or more of their three structural parts. Colors can be keyed in hue (all hues being closely related on the spectrum), saturation (all colors having the same level of saturation), or value (all having the same value). Keying a color arrangement in one or more color factors makes it visually cohesive (figs. 4.16–4.19 below).

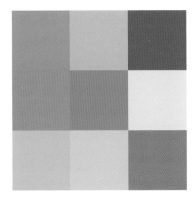

4.16 Nine colors keyed to hue (blue-green).

4.17 Nine colors keyed to value (mid value).

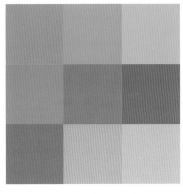

4.18 Nine colors keyed to saturation (muted colors).

4.19 Nine colors keyed to all three factors.

When a work of art or design is keyed according to value, and the overall value is dark, it is said to be in a LOW KEY. Conversely, if all the tones are predominantly light it would be considered HIGH KEY.

This painting by Ad Reinhardt (fig. 4.20) is constrained in hue, value, and, to a slightly lesser degree, saturation. Because its overall value is dark, it is in a low key.

Barbara Ellmann's encaustic painting (fig. 4.21) exemplifies a high-key color arrangement.

4.20 Ad Reinhardt, *Abstract Painting, Blue*, 1952, oil and acrylic on canvas. Carnegie Museum of Art, Pittsburgh.

4.21 Barbara Ellmann, *Rising Cloud*, 2010, encaustic on wood. Private Collection.

ASSIGNMENT 3: *Prismatic Color Studies*

3A. Make a painted-paper collage using six to nine shapes not including the background color. All the colors in this study must fall in the prismatic color saturation range. Both hue and value ranges should be broad. Again, use no color more than once. Remember that you can pull more than one color from each hue zone. As before, continue with the design you have established or continue with variations on a single motif.

Example:
The example shown in fig. 4.22 continues the same format used in samples for Assignments 1 and 2. It conforms to specifications, i.e. it has a broad range of hue and value.

3B. Make a second study in prismatic colors. Constrain or "key" the values to one or two sections of the value range as shown on a grayscale. Maintain a broad hue range.

Example:
With prismatic colors, the values are absolutely fixed to hue. Yellows are always the lightest and violets are the darkest. Consequently, the possibilities for keying the colors to a specific value are quite limited (fig. 4.23). Although no color is used twice, the differences in the greens and reds are slight. Not many hues are represented here, but the range is actually broad as it includes two sets of complements.

Prismatic Colors in Art and Design

Prismatic colors have an absolute and emphatic quality, like the crisp blast of a trumpet. We associate their use with folk art and the artwork of children. One seldom sees prismatic color in Western painting between the 15th and the 20th centuries. Naturalism based upon verisimilitude compels the artist to temper color tonalities to the overall atmosphere of the scene depicted. Look through a book on Dutch art of the 17th century, for example, and you might see the occasional rich vermilion, but only as a dramatic accent. Most of the colors fall in the chromatic gray or muted color categories.

In the 20th century, as artists moved away from naturalism and toward more stylized depictions of the world, prismatic colors became more common, admired for their strength and purity. The world was suddenly noisier and more crowded than in the past. One might say that the pendulum that swings from joy to misery, both public and private, began to swing to greater extremes in the 20th century. A broader palette of more emphatic color reflects that fact. Nevertheless, it is uncommon even today to find works of art or design that employ prismatic color exclusively, especially when a large number of colors are brought together. Prismatics tend to be used as strong notes in a field of duller colors.

4.22 Prismatic colors, broad value range, broad hue range.

4.23 Prismatic colors, narrow value range, broad hue range (includes complements).

ASSIGNMENT 4: *Combined Saturation Studies*

4A. Make a painted-paper collage using six to nine shapes not including the background color. In this study, employ all three levels of saturation: chromatic gray, muted color, and prismatic color. Both hue and value ranges should be broad. Again, use no color more than once. Continue with the design you have established or create variations on a single motif.

Example:
Figure 4.24 represents all three levels of saturation.

4B. Make a second study using all three levels of saturation. Key the values to one or two sections of the value range as shown on a grayscale. Maintain a broad hue range.

Example:
Fig. 4.25 combines all levels of saturation while keying all the values to a darkness well below mid-tone. The most saturated color is the green triangle in the upper left part of the design; the least saturated are the brown shapes. Because of the extreme saturation and temperature contrast in that juxtaposition, it is difficult to read the two colors as being of the same value.

Thomas Nozkowski paints images that are both poetic and formally ingenious. This playful little drawing (fig. 4.26) employs a full gamut of hue, value, and saturation.

4.24 Combined saturation levels, broad value range, broad hue range.

4.25 Combined saturation levels, narrow value range, broad hue range.

4.26 Thomas Nozkowski, *Untitled (N-10)*, 2010, ink and colored pencil on paper. Private Collection.

Additional Examples

The examples shown below and on the next page (figs. 4.27–4.34) answer the requirements of the first four assignments. Unlike the previous examples, these designs are variations of a single formal theme. The parameters are constant: Each one involves the arrangement of five shapes distributed across a field of color, no shapes touch each other or the edge of the format, and there are no curved lines. By establishing a set of rules and working within them, the designer has created a group of studies that are closely related but varied.

4.27 Assignment 1A: Chromatic grays, broad value range, broad hue range.

4.28 Assignment 1B: Chromatic grays, narrow value range, broad hue range.

4.29 Assignment 2A: Muted colors, broad value range, broad hue range.

4.30 Assignment 2B: Muted colors, narrow value range, broad hue range.

4.31 Assignment 3A: Prismatic colors, broad value range, broad hue range.

4.32 Assignment 3B: Prismatic colors, narrow value range, broad hue range.

Additional Examples (continued)

4.33 Assignment 4A: Combined saturation levels, broad value range, broad hue range.

4.34 Assignment 4B: Combined saturation levels, narrow value range, broad hue range.

After completing these first eight studies, you should understand the visual qualities of the different levels of saturation and be familiar with the basic color terminology needed to discuss your work structurally. You will likewise have gained the ability to make fine visual distinctions within a single color and in color relationships. You should also be more at ease with the mechanics of "building" a color through color mixing.

There are many insights to be gleaned from this series of assignments. Perhaps most important is the discovery that, even though hue, value, and saturation are distinct qualities and can often be manipulated independently, they also bear upon each other in various ways and to varying degrees. There is some predictability in mixing and combining colors, but there are also surprises.

In making these or any color studies, it is important to be alert to the unnamable qualities that emerge and affect the psyche of the viewer. Look at the eight studies you have just finished. Each one started out with a conceptual premise, but color relationships have a life of their own and each study has its own distinctly evocative quality.

FREE STUDIES

The color assignments in this book constitute a program of formal study that will help you gain confidence in your understanding. But in order to make the transition from a deliberate application of color principles to a freer, more natural approach, it is important to supplement the formal assignments with more self-directed explorations of color, using techniques that are in sympathy with your own disposition and studio preferences. In principle, these "free studies" can be done at any size and in any two-dimensional color medium.

For the sake of efficiency, however, there are good reasons to work within some of the same parameters that govern the standard assignments. We recommend, for example, that you continue to work in small-sized formats. The major benefit of working small is productivity: You can make several small studies in a short period of time and maximize your opportunities for color exploration. You will also be less likely to suffer the distraction of the technical problems that arise with shifts in scale or materials.

Also recommended is that you keep your design simple and maintain your focus on color. Free studies can be isolated "one-offs," but one can sometimes gain more valuable insight by creating groups of related studies bound together by a similar format or process. A series of free studies can be of any number.

One area of rich potential, even in these small formats, lies in the process of paint application. Feel free to explore both direct and indirect processes, e.g. stenciling, cut and torn collage, photomontage, stamping, blotting, and masking for sharp edges. While the formal assignments tend to call for flat, opaque color application, free studies can employ drips, drags, translucencies, and transparencies. They can be as wild and wooly or as classically constrained as you feel the need to make them.

The three free studies shown at right employ three distinct processes. Figure 4.35 combines directly applied gouache with collaged elements cut from maps and a paper palette.

Figure 4.36 uses a dribbling technique to deposit orange and gray paint across a graduated color field. Notice the value shift in dripped color as it passes over different background colors.

Figure 4.37 is painted directly with an emphasis upon a variety of edge qualities, from soft to razor-sharp. The color is subtle, mostly chromatic grays with a muted red-violet shape anchoring the composition.

4.35 Study by Laleh Khorraman.

4.36 Study by Kimberly Moody.

4.37 Study by Warren Bennett.

4.38 Studies by Vie Panyarachun.

Here are three sequences of free studies. Those shown in figure 4.38 are loosely painted with a vigor reminiscent of Abstract Expressionism.

The two printlike studies in figure 4.39 were made by a graphic design student who purchased some wooden type at a yard sale. He created a large number of these studies, stamping the wooden type in combination with the techniques of blotting and direct painting to produce a cohesive body of work.

The studies shown below (fig. 4.40) are part of a series of methodical studies in color proportion. The student used removable tape to mask off the sharp edges of her stripes.

4.39 Studies by Matthew Palen.

4.40 Studies by Maria O'Callahan.

5. COLOR INTERACTION

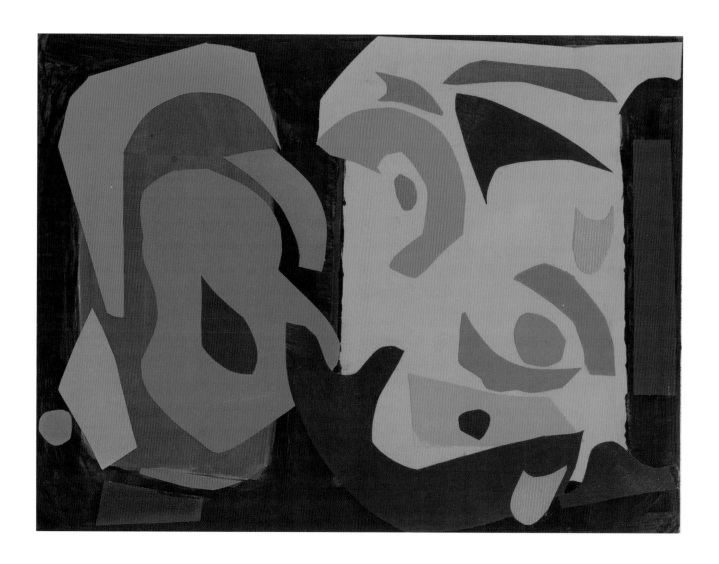

"In visual perception a color is almost never seen as it really is — as it physically is. This fact makes color the most relative medium in art."

Josef Albers, *The Visual Nature of Color*

AFTERIMAGES

Painters commonly experience the surprise of carefully mixing a color on the palette and then seeing it change when it is placed among other colors in a painting. The appearance of a color is affected by its neighbors, sometimes subtly, sometimes dramatically. This is caused by an aspect of vision that makes a halo effect called an AFTERIMAGE appear to surround individual shapes of colors and noncolors (black, white, and achromatic grays). We are not normally conscious of this phenomenon, but it is present wherever one shape meets another on a flat surface. In fact, despite our lack of awareness of them, the cumulative effect of multiple afterimages in a painting or a design enriches our visual experience.

The following experiments require visual concentration. To begin, stare at the black circle at right for about twenty seconds, and then shift your gaze to the white area within the box below the circle. The afterimage will appear as a very bright white circle of the same size as the black one. This optical phenomenon is called successive contrast.

Now stare at the black circle again. Repeat the original action but, this time, when you see the circular white afterimage, concentrate on its outer edge. The afterimage will itself be surrounded by a weak but perceptible dark-gray aura. What you now see is the afterimage of an afterimage. "Optical echoes" of this kind reverberate subtly throughout any combination of contiguous colors.

Finally, concentrate on the black circle and, without shifting your gaze, notice the bright white halo flickering around its edge. (Some students have suggested that the black circle with its white nimbus resembles a solar eclipse.)

Achromatic Afterimages

At the border between two colors we see two simultaneous afterimages. Look closely at the border between the dark and light rectangles in figure 5.1. On the darker side of the border you will see an even darker band. At the same time, a lighter band will appear on the inside edge of the lighter rectangle. Figure 5.2 depicts how both afterimages can be seen simultaneously. This phenomenon is known as SIMULTANEOUS CONTRAST.

5.1

Because achromatic grays lack hue and saturation, their mutual afterimages contain only value. When a dark gray casts an afterimage upon a light gray, the afterimage will be lighter in value than the light gray. Conversely, the afterimage cast by a light gray on a darker gray will be darker than its darker neighbor. This holds true even with black and white. The halo surrounding the black circle on a white page is whiter than white, and the blackness on the inner edge of the dot is blacker than black.

5.2

Afterimages in Full Color

The lightness or darkness of an afterimage cast by a color conforms to the same rules that govern the afterimages produced by black, white, and achromatic grays. As with noncolors, dark colors project light afterimages upon light colors. The difference with color, however, is that the afterimage also contains hue.

Recreate the "black circle" experiment with the prismatic blue circle and white box seen at right. Its afterimage is not only lighter than that which you see within the square, but it also has a discernible hue, that of blue's complement: orange.

If the blue circle is placed against a lighter achromatic gray (fig. 5.3), the afterimage that surrounds it will contain its complement (orange) but will also be lighter than the gray it falls upon. Furthermore, the inside edge of the blue circle reveals a thin ring of darker blue. The gray, being achromatic, influences only the value of the blue and not its hue. Figure 5.4 depicts this illusion.

More Examples

Look closely at the blue-violet circle against the green square (fig. 5.5). Immediately inside the blue-violet circle is a thin ring of red-violet. The reddish afterimage of the green is blended optically with the blue of the circle to create this red-violet illusion. Compare the same blue against gray (fig. 5.6). Here with no green to redden it, the circle appears bluer.

In figure 5.7 a violet circle is seen against a dark red-orange. Here, the violet appears lighter and a little bluer than it does against pale green (fig. 5.8), where it looks darker and redder.

The orange diamonds seen below (fig. 5.9) are physically identical but, due to COLOUR INTERACTION, appear to differ markedly when seen against three different background colors.

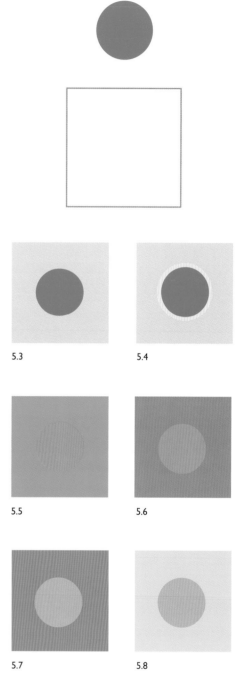

5.3 5.4

5.5 5.6

5.7 5.8

5.9 An orange diamond appears to change when seen against three different background colours.

OPTICAL MIXING

When a field of color is composed of small, particulate color shapes, your mind fuses the disparate visual phenomena into a comprehensible whole. This is called OPTICAL MIXING. The size of the color increments and their distance from the eye determine how seamlessly the parts can congeal. Four-color printing, digital imaging, and color photography all involve the visual synthesis of thousands of tiny dots or flecks of color (fig. 5.10). In these cases, the dots are so small as to be barely visible, if at all.

Sometimes, as with mosaics and woven textiles, the individual units of color are big enough to be seen, yet still manage to meld into a larger cohesive image. This presents the viewer with a "dual visual awareness," which means he or she can alternate between two readings: the physical reality of the color increments and the pictorial reference called up when they coalesce into a picture. This sensation can make the act of seeing seem almost tactile.

The detail of a mosaic from Ravenna (fig. 5.11) demonstrates this dual mode of vision. The mind blends individual color fragments into larger tonal masses so that the face of the youthful Jesus can be read either as a visage or as an aggregate of colored bits. Greater distance (or smaller color fragments) would favor the more illusionistic interpretation, while less distance would make the image more abstract.

Chuck Close made his reputation with large and powerful portraits executed in a Photorealist syle. But his experimentation in both drawing and painting has taken him well beyond the transcription of the photograph into an exploration of the nature of vision itself.

In recent years Close has been painting large-scale portraits comprised of myriad small squares and rectangles, each housing a jot or squiggle whose seemingly random configuration appears to be quite independent of its neighbor, especially at close range.

But the colors in each square conform to the logic of the original photograph so, at a distance, the riotous marks congeal into a photographic visage. The example here (fig. 5.12) is wonderfully dualistic and demonstrates the mind's ability to organize complex and disparate visual information into a cogent synthesis.

5.10 A magnification of four-color printing that shows the breakdown of the image into colored dots.

5.11 Maker unknown, *Head of Youthful, Clean-Shaven Jesus*, detail of *The Widow's Mite*, 6th century mosaic. S. Apollinare Nuovo, Ravenna.

5.12 Chuck Close, *Self-Portrait*, 2004–05, oil on canvas. Pace Wildenstein, New York.

Afterimages Enhancing a Pattern

Sometimes an afterimage can become part of a design, especially when it is repeated in a pattern. In figure 5.13 a light, achromatic gray field is covered by a grid of smaller, darker gray squares. Stare intently at the intersections of the small squares and you will notice even smaller, vaguely circular shapes emerging (fig. 5.14). These afterimages are an optical illusion, but they play a dependable role in animating what would otherwise be a rudimentary pattern design. Notice that the value of the afterimages is midway between that of the light-gray field and the small darker squares.

5.13

5.14

5.15

5.16

The same phenomenon is repeated in figure 5.15 with two colors in place of the two achromatic grays. Again, the afterimage provides a lively foil to the rigidity of the grid and, again, its value is more or less halfway between that of the light-blue field and the orange squares. This time hue is also a factor. The afterimage at the intersections combines the light blue of the field with the orange of the squares to make a neutral hue (fig. 5.16).

Here, the same motif is used again (fig. 5.17). This time, because the values of the two colors are close, there is no afterimage at the intersections of the blue-violet grid. Instead, look for fleeting, flickering glimpses of medium yellow within the orange squares.

5.17 Look for flickering yellows within the orange squares.

Interaction and Tonal Progression

When combined with color progression, the effects of simultaneous contrast can be striking. The constant blue-green band in the progression below (fig. 5.18) appears to change as it moves from left to right.

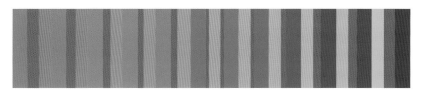

5.18 The blue-green stripe is physically constant but appears to shift in color.

In figure 5.19 a series of vertical stripes are shown to be a consistent blue. In figure 5.20 the shifting background color variously transforms the same blue stripes.

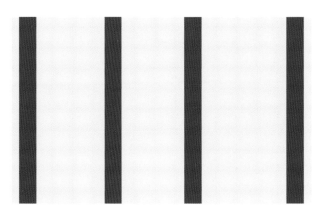

5.19 The repeated violet stripe shown here...

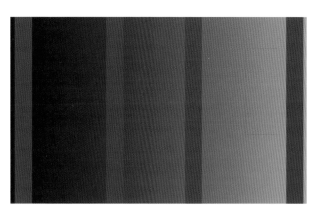

5.20 ...appears to change against a gradient.

JOSEF ALBERS

Josef Albers was the most influential color educator of the second half of the 20th century. He began his career at the Bauhaus in Germany, where he was a student and an instructor. Emigrating to the United States in 1933, he made his greatest impact on American art and design through his teaching at Black Mountain College and later at Yale University. In 1963, he published a limited-edition book of silkscreened color studies titled *Interaction of Color*. This seminal work was Albers' enduring pedagogical achievement.

The original edition is more than a book. It is a rich repository of discoveries made by Albers and his students over the course of several years. Albers' text has considerable charm because it reflects his sense of wonder at the mystery of color relationships.

One of Albers' classic experiments was to make one color appear as two. His favored motif was the square within the square. First, he would show what appeared to be two smaller squares of differing tones against two different background colors (fig. 5.21). Then he would mask out the backgrounds with white, revealing that the small squares were physically identical (fig. 5.22).

Albers was fascinated by the subtle and unpredictable nature of color interaction. He believed that only through careful and sustained experimentation with color relationships could one attain a significant understanding of their intricacies. Albers' teaching method was elegant: a regimen of closely observed color events staged within a controlled setting.

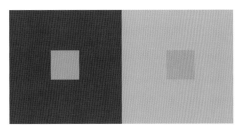

5.21 One color appears to change as its context changes.

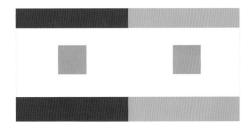

5.22 A white mask reveals that the two colors are the same.

Albers quotes:

"In visual perception a color is almost never seen as it really is – as it physically is. This fact makes color the most relative medium in art."

"As basic rules of a language must be practiced continually, and therefore are never fixed, so exercises toward distinct color effects never are done or over. New and different cases will be discovered time and again."

"Any ground subtracts its own hue from the colors which it carries and therefore influences."

"Simultaneous contrast is not just a curious optical phenomenon – it is the very heart of painting."

RATIONALE FOR ASSIGNMENT FIVE

Because of the nature of color vision, a single color can appear to change in hue, value, or saturation when seen in a variety of contexts. Sometimes the change is very subtle, sometimes it is dramatic enough to strain belief. The following studies are designed to explore the optical effects colors impose upon each other and to reveal some of the principles that govern color interaction.

ASSIGNMENT 5: *Color Interaction Studies*

Try to make a single color appear as two different colors by altering its surroundings. Use color swatches and collage construction for this assignment (you will have swatches saved from Assignments 1–4; mix new ones where needed). This experiment requires close observation, repetition with small adjustments, and a conscious engagement with what you encounter. As you observe color effects, try to reason out the cause. This work demands full submersion into the visual experience of color. A quiet work environment with no distractions is recommended.

5A. In this first group of five studies, you will be trying to alter the value of a color. For your first one, work only with a chromatic gray (made from intermixing your chromatic darks with white): This way you will only be altering value, not hue or saturation. What you learn about altering value will continue to apply when working with full colors. To produce five strong examples, you will need to make many more than that. Take your time and enjoy the exploration.

Each of these interaction studies will involve two large squares (2 x 2 inches or 5 x 5 cm) and two smaller ones (1/2 x 1/2 inch or 1.25 x 1.25 cm). Organize your studies as seen below at actual size (fig. 5.23).

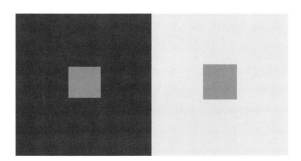 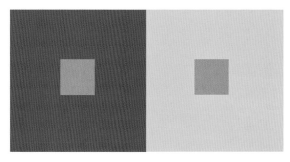

5.23 Two examples of altering the value of a small square by placing it in two diverse contexts. The one on the left is achromatic and, on the right, chromatic.

5B. For the second group of five studies, try altering only the hue of a single color; value should remain the same. Again, be prepared to make many examples to get five excellent ones; explore colors at all levels of saturation. As you work, think about what you discover and try to make sense of it.

Example:
In figure 5.24, the small center square is physically the same in both instances. But against the blue background it appears red-violet, and against orange it appears blue-violet. The value of the square remains relatively constant, as does its saturation.

If you think about the hues involved here, the color of the center square shares a different color with each of the two backgrounds. Notice that blue and orange are complements and that blue is a primary color (consisting of one part) while orange is a secondary color (two parts: red and yellow). The violet in the center is also a secondary color which combines red and blue. So violet shares blue with the blue background and red with the orange background.

A background color will "drain" its own color from a color that is superimposed upon it. Therefore, blue will drain some of the blueness from the violet, leaving the red looking more emphatic. Likewise, orange (which contains red) will drain some of the redness from the violet, making the blue look stronger. As Joseph Albers said: "Any ground subtracts its own hue from the colors which it carries and therefore influences."

Looking at this example, see if you can figure out why the value of the center color is unaffected.

5C. Make five studies that show an alteration of saturation predominantly. Minimize, as much as possible, shifts in hue or value.

Example:
Shifting saturation conforms to the same logic as the alteration of hue; much depends on the pull of a background color upon the color that rides over it. In figure 5.25, the center square appears duller on the right against a chromatic gray of a similar hue and more highly saturated against a yellow-green with which it shares very little.

An interesting variation of figure 5.25 results from putting the duller violet in the center and moving the more saturated red-violet to the background on the right (fig. 5.26). Again, the yellow-green background makes the center square appear more saturated, but it also affects the smaller square's hue, making it appear more red. The value of the two squares differs slightly as well: The one shown against red-violet looks lighter. Can you explain why?

5.24 Color interaction emphasizing a change in hue.

5.25 Color interaction emphasizing a change in saturation.

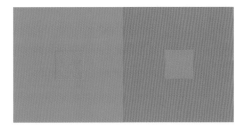
5.26 A variation on figure 5.25.

5D. Produce five studies that appear to alter the hue, value, and saturation of a single color as shown at right (fig. 5.27).

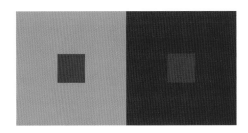

5.27 Color interaction with visible changes in hue, value, and saturation.

5E. An even greater challenge is to try to make two different colors appear as one (fig. 5.28). Using what you have learned, make five studies of two colors as one.

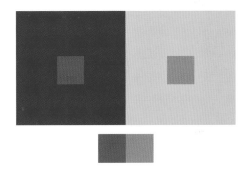

5.28 Two colors appear as one.

Making the Most of a Limited Number of Colors

Working purposefully with a strictly limited number of colors can lend a sense of clarity and unity to a color composition. The contempory quilt shown at right (fig. 5.29) uses the same few colors repeatedly in shifting contexts, resulting in surprising variety and richness. If you squint at this design, you can easily see how the light pinks on the left merge into a background while, on the right, they float out on the surface. The mid-value yellow-green reverses this transition: It floats out on the left and sinks in on the right. It also appears darker against the light pinks on the left and lighter against the dark reds on the right.

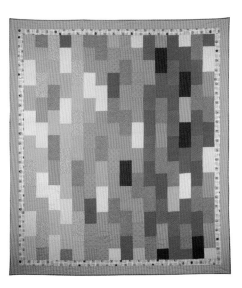

5.29 Lydia Neuman, *Cobblestones: Pink and Green*, 2002, pieced cotton. Collection of Michie McConnell, Berkeley, California.

Textile artists are sometimes restricted to a small number of specific flat colors. This poses a challenge to the designer's ability to create a sense of variety within strict limitations. The traditional textile design shown in figure 5.30 employs only the eight flat colors stacked on the far right. From these few colors the artist has created an intricate and spatially complex pattern wherein colors seem to change in relation to their immediate color context.

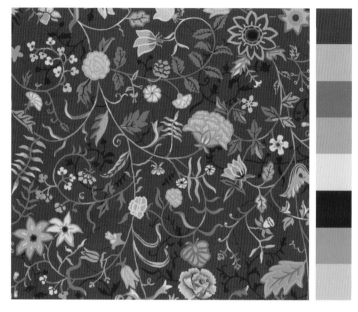

5.30 Textile design by Jonathan Box. Courtesy of the Artist.

Artists and designers occasionally impose color restrictions upon themselves as a creative strategy to great effect. In his graphic novel *Asterios Polyp*, David Mazzucchelli uses restricted color as both a visual and narrative device. Each episode in the protagonist's story has its own distinct palette, often limited to only two hues. Throughout the book, Mazzucchelli forgoes the conventional black outline normally associated with the medium to create a cooler, more fluid visual universe.

In the page from the book shown at right (fig. 5.31) Mazzucchelli depicts a dramatic scene using only blue-violet and deep yellow. The simplicity of the color tightly unifies the image and, at the same time, undercuts its emotional impact with a layer of ironic detachment that perfectly reflects the main character's analytical temperament.

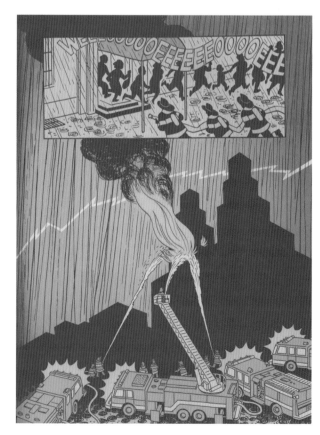

5.31 David Mazzucchelli, *Asterios Polyp*, Pantheon Books, New York, 2009.

RATIONALE FOR ASSIGNMENT SIX

The goal of this assignment is to maximize the effect of a limited number of colors in a single design through color interaction and proportional variation. Unlike most designs, which begin with the organization of shapes and intervals, this composition gives color organization top priority.

ASSIGNMENT 6: *Interaction Composition*

Using a minimum of six colors twice, create a design that demonstrates the contextual nature of color identity. As in the previous "one color as two" studies, arrange your color relationships to alter the way they look in each location. Feel free to use color combinations from the previous assignment as source material. The format should be small, no greater than 48 square inches (310 square cm).

Examples:
In the first example (fig. 5.32), seven colors are each used twice. Each color appears different in hue, value, or saturation depending on its surrounding color. The second example (fig. 5.33) also employs seven repeated colors, but the yellow in the lower left corner only appears once. The highly animated design at bottom right right (fig. 5.34) has nine colors, each repeated at least once.

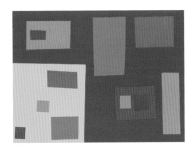

5.33 Interaction composition study.

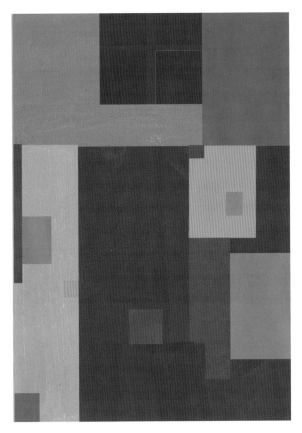

5.32 Interaction composition study.

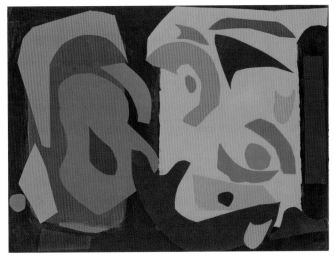

5.34 Study by Virginia Dow.

SEPARATING COLORS WITH LINE

Color shapes can be separated from each other by surrounding them with achromatic white, black, or gray, as in tiles that are separated by grout or stained glass held together with lead binding. Certain kinds of illustration, e.g. comic books and traditional children's books, bind shapes with black line and, by "coloring within the lines," isolate the colors.

Such separation prevents neighboring colors from interacting. In figure 5.35, the muted green color in the center appears to differ significantly in each of the two larger squares. Against the dark blue, it appears lighter in value and more yellow in hue. But when the same green is surrounded by a white line (fig. 5.36) or a black line (fig. 5.37), the colors do not touch and therefore seem to be more independent of each other. In cases like these, the thicker the dividing line, the less the colors can interact.

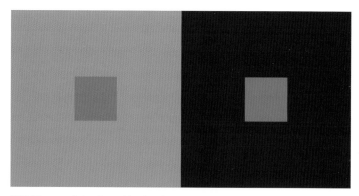

5.35 The green is transformed by changing contexts.

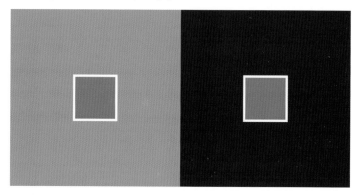

5.36 When the small square is surrounded by white, the difference is less noticeable.

5.37 A black surround also interrupts the effect of color interaction.

Look again at the afterimage surrounding the blue circle when seen against white and black (fig. 5.38) and you will discover that there is a significant difference. Against white, the haloed afterimage appears to be lighter than the white around it and clearly of a yellow-orange cast. Against black, the afterimage appears darker than the surrounding black. A white background receives the hue of a color's afterimage much more visibly than a black background.

5.38 A comparison of blue against white and black backgrounds.

In the three versions of the same design shown at right (figs. 5.39–5.41), you can see the way achromatic outlines simplify the overall color of the design by circumventing color interaction.

The effect of white and black lines differs, however. With white lines, the colors, while isolated, appear open and expansive. Although you are not specifically conscious of it, your eye experiences each color's afterimage flaring out into the line. As a result, the design looks open and airy.

Conversely, black lines contain the colors. There are no flickering afterimages, just a darkening of the black where it touches the color. The overall impression is one of tight precision.

5.39 With no outlines to divide them, colors interact freely.

5.40 White outlines let "air" into the design.

5.41 Black outlines contain colors.

FREE STUDIES

You might carry some of the ideas you encounter in the assignments into your free studies, as in the examples shown below (figs. 5.42–5.45), or you can simply use them as an opportunity for broader experimentation as seen on the next page (figs. 5.46–5.49).

5.42 Study by Kate Decarvalho.

5.43 Study by Jamie Wilen.

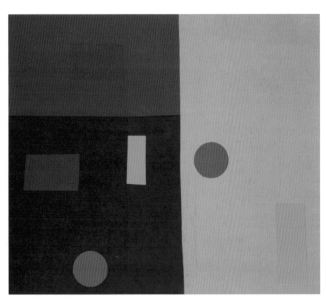

5.44 Study by Dori Smith.

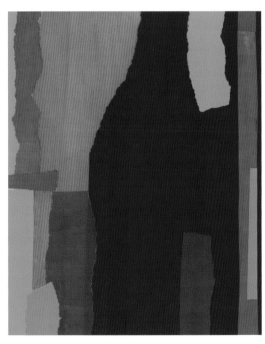

5.45 Study by Valerie Britton.

5.46 Study by Kim West.

5.47 Study by Alexis Mahon.

5.48 Study by Mary Sullivan.

5.49 Study by Ryan Coughin.

6. APPLYING COLOR PRINCIPLES

"It is well to remember that a picture, before being a battle horse, a nude woman, or some anecdote, is essentially a plane surface covered with colors assembled in a certain order."

Maurice Denis

The lessons of Parts One to Five have prepared you for more challenging studies designed to enhance your grasp of fundamental color principles by applying them to specifically defined goals.

The next three assignments address, in sequence, color progression, the illusion of transparency, and a color-based approach to observational painting. They all require refined judgment and precise color mixing and will deepen your understanding while introducing color strategies useful in two-dimensional art and design.

TONAL PROGRESSION

The most familiar tonal progression is the standard grayscale. Grayscales usually consist of ten or 11 evenly spaced shades that run from black to white. Painting an achromatic grayscale is a common feature of introductory design curricula. The grayscale itself can be a practical tool, but it is a progression in value only.

Progressions can also happen within hue or saturation, or in combinations of all three structural factors. They need not run a full gamut of extremes, but can be visually effective in tighter, more constrained transitions. In fact, progressions that cover a limited distance within a larger range of tones can make for more subtle, evocative effects as in figures 6.1–6.3.

In figures 6.4, 6.5, and 6.6, we see progressions in several structural categories simultaneously. Figure 6.4 shows a broad progression in hue and saturation with prismatic complementary hues at each end. It includes the full range of saturation. Value transitions are minimal.

In figure 6.5, there is a narrow shift in hue (yellow to red) and an equally narrow shift in value. The transition in saturation is very slight because all tones are in the muted color range.

Figure 6.6 shows a dramatic transition in hue, but more subtle shifts in value and saturation.

6.1 A progression with subtle transitions in hue and value.

6.2 A progression with subtle transitions in hue and saturation (chromatic gray to muted color).

6.3 A progression in hue from blue to green.

6.4 A progression in hue and saturation.

6.5 A progression in hue and value.

6.6 A progression in hue, value, and saturation.

Informal Tonal Progression

The discussion has so far centered on formal, tightly controlled tonal progressions strictly arranged in even increments. But color progression can also be applied in a less formal manner and still manifest the special qualities of movement and luminosity that they instill in art or design work.

Instead of blending colors to create the illusion of form, Paul Cézanne carefully mixed tonal progressions that lend a paradoxical sense of solidity and flux to his pictures, as shown in figures 6.7 and 6.8.

In traditional decorative arts, e.g. tapestries, rugs, and mosaics, discrete particles of color information are arranged as progressions to depict the structure of forms and the play of light across their surfaces (fig. 6.9).

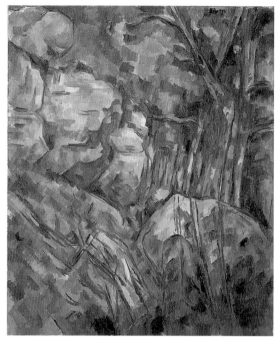

6.7 Paul Cézanne, *Rocks near the Caves above the Château Noir*, c. 1904, oil on canvas. Musée d'Orsay, Paris.

6.8 Detail of figure 6.7.

6.9 Maker unknown, detail of *The Widow's Mite*, 6th century mosaic. S. Apollinare Nuovo, Ravenna.

Interspersing Color Progressions

Two distinct color transitions can be interspersed by alternating their sections to create a compelling visual effect (as shown in figures 6.10, 6.11, and 6.12).

The two progressions shown here are quite different. Figure 6.10 has the same prismatic red at each end, with saturation diminishing in steps toward the middle. There is little transition in value.

The progression in figure 6.11 is a little more conventional. Its value shifts from dark to light in the manner of a traditional grayscale. The hue transition is dramatic too, moving from violet to yellow in ten increments. All three levels of saturation are present as well, with prismatic colors at the poles and chromatic gray at the center.

The result of interpositioning figures 6.10 and 6.11 can be seen in figure 6.12. Integrating the two sequences reveals the effects of color interaction. The prismatic reds at top and bottom differ strikingly in value while the cooler colors in the center of the sequence appear to drop back behind the reddish chromatic grays.

Progressions can be seen as an analogue for movement and change. Simple and complex color progressions are found in textile, package, label, and interior design, and in all kinds of printed matter. A third color is often used to soften the transition between contrasting tones.

6.10 A progression in saturation.

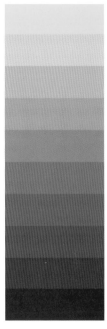

6.11 A progression in hue, value, and saturation.

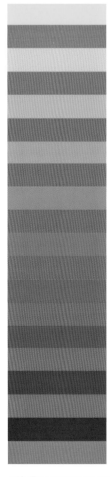

6.12 Two interspersed progressions.

RATIONALE FOR ASSIGNMENT SEVEN

Painting and assembling tonal progressions will refine your color mixing skills while sharpening your understanding of color structure. By thinking of these studies "three-dimensionally," i.e. in terms of hue, value, and saturation, you can create surprising and beautiful controlled color effects. This two-part assignment asks that you approach progression, first, as a strict sequence of color intervals and, second, in a format of your own invention.

ASSIGNMENT 7: *Color Progression Studies*

7A. Paint two separate sequences of color on vertical rectangles approximately 4 inches (10 cm) wide. The height of each set of bands need not be uniform. (In the examples at right [figs. 6.13 and 6.14], the height of the bands varies. The sequence of tones in figure 6.13 occurs in even vertical increments, while that in figure 6.14 is uneven.) Each progression should involve at least two structural factors, e.g. hue and value or value and saturation. Also, experiment with varying the range of contrast among the factors you are bringing into play. For example, the hue progression in one of your sequences could run the gamut between two complements, while the transition in saturation might be far more subtle, moving from a dull muted color to chromatic gray.

When you have completed the two sequences, bisect them vertically so that each progression is 2 inches (5 cm) wide. One set of each sequence will stay intact and appear as in figures 6.13 and 6.14. The second set should then be carefully cut into horizontal strips and reassembled as in figure 6.15, with the two sequences interspersed.

7B. Create a design that incorporates tonal progression as a central design feature. Consider introducing progression to other design variables, e.g. size, shape, or interval (fig. 6.16). Or try to experiment with very subtle transitions as in figure 6.17.

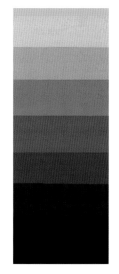

6.13 Progression #1.

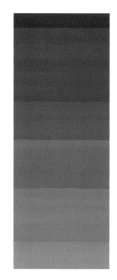

6.14 Progression #2.

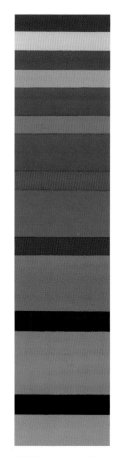

6.15 Progressions #1 and #2 interspersed.

6.16 Study by Leslie Jones. Transition in size complements color progression.

6.17 Study by Ilivia Yudrin. A progression study with subtle shift in color temperature.

COLOR AND THE ILLUSION OF SPATIAL DEPTH

The illusion of spatial depth in two-dimensional art and design is produced by visual devices. These include overlapping shapes, relative size, relative edge definition, simple linear convergence, and linear perspective. Relationships of hue, saturation, and, to a lesser extent, value can also contribute to the illusion of depth in a design or image.

Using a grid format, to establish color alone as the spatial determinant, we can demonstrate how hue, saturation, and value can assert the illusion of spatial depth on a flat plane. In figure 6.18, we see colors that are close in value and saturation. The warmest colors (orange and scarlet) seem to advance, while the coolest colors (blues and violets) appear to sink into the picture plane. Remember that temperature is an aspect of hue (see pages 22–23).

In figure 6.19, colors that are close in hue and value, but disparate in saturation, are arranged in a grid. While most of them are muted, two green squares are highly saturated. These two squares seem to advance while the others recede.

Examine the grid of tones in figure 6.20 and try to determine which ones advance and which recede. All 16 colors are close in saturation and hue; the values alone are varied. Unlike hue and saturation, value is not an effective indicator of depth of field. In figure 6.20, the dark squares sometimes seem to advance, but they can also be perceived as "holes" in the fabric of the grid.

While value contrast does less than hue or saturation to assert the illusion of depth, it clearly delineates the boundaries of shapes when the eye moves across a visual field. That is why chess boards are normally made up of alternating dark and light squares. (Imagine figure 6.18 serving as a game board!)

In practice, artists and designers draw upon the full panoply of visual clues to assert a spatial hierarchy and are seldom limited to using color alone. In Western art, particularly from the High Renaissance up until the late 19th century, the entire toolbox of spatial indicators was employed consistently to support the illusion of "realistic" three-dimensional space.

At the end of the 19th century, artists in Western Europe became interested in the pictorial vocabularies of non-Western art. They were also attracted to pre-Renaissance examples of Western art, e.g. medieval icons and early illuminated manuscripts. In other traditions, illusionism was often considered secondary to graphic invention. Color, in particular, was liberated from serving the spatial imperatives of drawing. The discovery of alternate pictorial conventions in Eastern art by Western artists helped to set the stage for major innovations in 20th-century art.

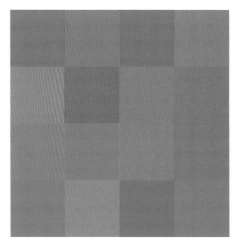

6.18 Hue: Warm colors advance, cool colors recede.

6.19 Saturation: Rich colors advance, dull colors recede.

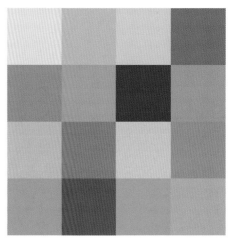

6.20 Value: Contrast in value asserts depth of field less reliably than contrast in hue or saturation. Instead value contrast delineates the boundaries that define shapes of color across a visual field.

The examples at right show two different versions of an industrial scene. In figure 6.21, value contrast makes it easy to read distinct color shapes, but there is no attempt to use color to suggest a sense of deep space. In figure 6.22, warmer, more saturated color has been added to the foreground to emphasize the illusion of spatial depth.

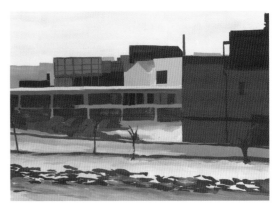

6.21 Study by Nathalie Shepherd.

6.22 The addition of warmer, more saturated color to the foreground enhances the illusion of spatial depth. Alteration of figure 6.21 made by author.

This richly evocative painting by Paul Klee (fig. 6.23) is strictly based on a perpendicular grid inhabited by a series of rectangles of varying size and proportion. Each shape asserts its frontality and agrees with the flatness of the picture plane. But the color tells a different story. The highly saturated red near the center steps boldly forward and brings the pastel blues and greens immediately to its right with it. (Cover the red rectangle with your finger and you'll discover how much more equivocal the spatial location of the surrounding colors becomes.)

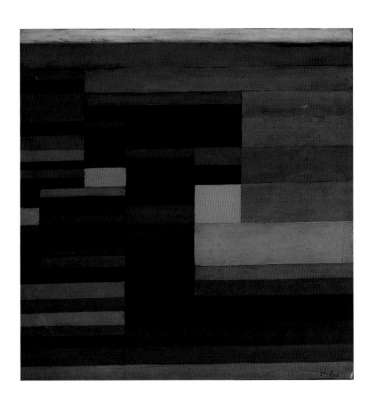

6.23 Paul Klee, *Fire at Evening (Feuer Abends)*, 1929, oil on cardboard. The Museum of Modern Art, Mr. and Mrs. Joachim Jean Abervach Fund.

RATIONALE FOR ASSIGNMENT EIGHT

Drawing upon the discussion of color space on the previous two pages, in Assignment 8A you will establish a "front-to-back" spatial hierarchy, in a simple abstract image.

In Assignment 8B, using the same format, that spatial order will be overturned when you deliberately pit the color arrangement against the spatial indications of shape and scale.

This assignment is designed to reinforce your understanding of the role hue and saturation, in particular, play in the illusion of space in two dimensions.

ASSIGNMENT 8: *Color Space Study*

8A. Create a small image of no more than 46 square inches (297 square cm) that consistently asserts the illusion of space. Use only nonpictorial flat shapes and the rudimentary spatial indicators of overlapping shapes and size variations to establish a spatial hierarchy in your design. Applying what you know about the effects of color temperature and saturation on pictorial space, use color in a way that agrees with the spatial order you have set up in the design.

Example:

In figure 6.24, hue and saturation are in complete agreement with the disposition of overlapping shapes and size relationships. Warm, highly saturated hues advance, while cooler, duller colors recede.

8B. Now, using the same design and the same colors, reorder hue and saturation to make them contradict the logic of overlapping shapes and relative size.

Example:

Figure 6.25 shows the same design with the same colors reordered to contradict the linear logic of the design. Shapes that, given their size and position, should be read as in the foreground are now colored in contradiction to that spatial assertion.

When spatial clues contradict each other, a tension is set up on the picture plane. The influential painter and teacher Hans Hofmann labeled this tension "push-pull" and ascribed it considerable significance in the lexicon of abstract painting.

Figure 6.24 is "deeper" because the linear clues and color arrangement are in concert with each other. Figure 6.25 is spatially contradictory. (When comparing these examples, put a piece of white paper over the one you are not viewing for greater clarity.)

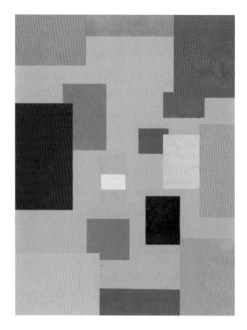

6.24 Spatial study: color in agreement with relative size and overlap.

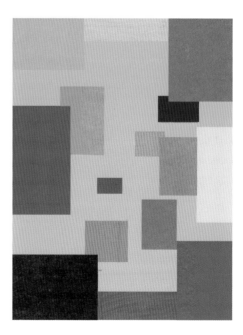

6.25 Spatial study: color contradicting relative size and overlap.

ILLUSIONS OF TRANSPARENCY AND SPACE

Imagine two translucent colored rectangles superimposed at right angles to form a cross (fig. 6.26). Where the rectangles intersect there is a square. The color of this central square determines the effectiveness of the illusion.

There are two distinct categories of transparency illusion useful in design applications: MEDIAN TRANSPARENCY and DARK TRANSPARENCY. In median transparency, the hue and value of the overlapping area (the center of the cross in figure 6.26) lie precisely halfway between the hue and value of the two parent colors (the wings of the cross). At right, a light yellow traverses blue and the square in the center is a median value between that of the yellow and blue. The hue of the central square is green, halfway between lemon yellow and blue on the spectrum.

Dark transparency is so called because the value of the color at the overlap of two "translucent" colors is darker than both of them. For example, when a dull orange and a blue-green of similar value "overlap" (fig. 6.27) the square at the intersection is darker than both the orange and the blue-green. The hue, however, should be a median hue that combines those of both parent colors.

The illusion of transparency can enhance the appearance of spatial depth on a two-dimensional surface when using the flattened visual language common to graphic and textile design, as shown in figures 6.28 and 6.29. (Note: We are talking about the illusion of transparency created with opaque color, not the literal transparency of watercolor washes or the layering of colored films.)

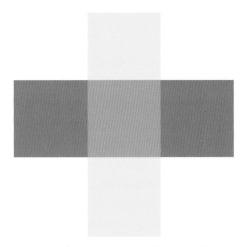

6.26 In a median transparency, the value and hue at the overlap are midway between those of the parent colors.

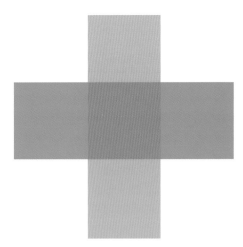

6.27 In a dark transparency, the intersection is darker in value than the two parent colors but precisely midway between them in hue.

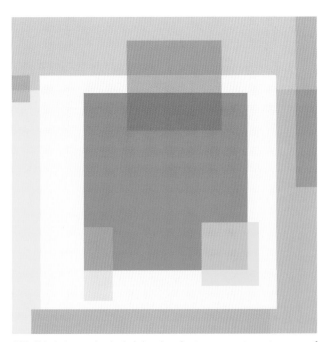

6.28 This design employs both dark and median transparency to create a sense of overlapping shapes and the illusion of space on a two-dimensional surface.

6.29 A second example of a composition that has both dark and median transparency.

OBSERVING AND TRANSCRIBING COLOR

In the late 19th century, the French Impressionists revitalized the role of color in painting. Inspired by encounters with Eastern art and new ideas about optics and color theory, they developed a way of painting that, at its most extreme, sought to replace drawing with the unbiased observation of color as the basis of pictorial representation.

Claude Monet proposed that the painter should record only the shapes and colors that fall on the retina and ignore preconceived notions about the identity of the subject (see figs. 1.15 and 1.16 on p.19). In doing so, he could construct an image that more truthfully represented "what he saw." This constituted a new kind of realism that was rooted in the physical nature of vision.

In this course of study, we call Monet's approach RETINAL PAINTING. In retinal painting, you concentrate upon color and shape while resisting the urge to see objects as independent visual entities. When your efforts are directed in this manner, you actually experience visual reality with a different standard for verisimilitude: one that values seeing over knowing.

The best-known American practitioner of retinal painting in the latter part of the 20th century was Fairfield Porter. Early in Porter's career his paintings were somewhat linear and rooted in drawing. His color was conceived in terms of value and consciously organized to describe what he knew about three-dimensional form.

The head shown in figure 6.30 is a good example of Porter's early style. It demonstrates his interest in an almost sculptural solidity and is nearly monochromatic.

Compare that head to the one in figure 6.31. This later painting is less insistently sculptural and seems to be bathed in atmospheric light. Here Porter is focusing on the precise relationship between the color tonalities he is seeing. Subtle hue shifts flicker within the chromatic grays that make up the shadows. In the later painting, Porter simply reads the color he sees and transcribes it without preconceptions about form.

6.30 Fairfield Porter, *Seated Boy*, 1938, oil on masonite. Parrish Art Museum, Southampton, NY. Gift of the Estate of Fairfield Porter (detail).

6.31 Fairfield Porter, *Anne, 1971*, 1972, oil on masonite. The Parrish Art Museum, Southampton, NY. Gift of the Estate of Fairfield Porter.

RETINAL PAINTING

What we call "retinal painting" is a direct approach to painting from observation. But, despite its directness, it can be more difficult than you might think. To surrender completely to visual sensation feels out of control at first. Most people find it hard to overcome the visual habit of imposing "what they know" about the subject upon what they are actually seeing.

In 1991, Harriet Shorr published a book of her paintings and her insights into the painting process called *The Artist's Eye*. In it, she advocates an approach to observational painting from life predicated upon the careful rendering of color shapes and their transitions which she calls "perceptual painting." Shorr writes, "When I am looking at a pink cup on a yellow cloth, I know that it is round, that there is a certain distance from the edge of a purple scarf. What I see is a specific shape surrounded by another yellow shape, and this yellow shape meets a purple shape. My eye sees shapes, colors and tones."

In figure 6.32, we see another contemporary painter working directly from life in a retinal manner. Jennifer Maloney, like Harriet Shorr, paints what she sees. She takes delight in the subtle nuances of color that she finds in her subject and allows them to construct the form. Maloney's subject is starkly lit, this time from the front. The shadows are rendered as a series of precise tones echoing the stitched leather circles that comprise the top of the shoes.

6.32 Jennifer Maloney, *Monaghan Size 7*, 2008, oil on canvas. Courtesy of the artist.

Retinal Painting from a Photograph

Many contemporary artists use photography as a source. It is particularly useful for getting to subjects that are unavailable to the kind of sustained scrutiny that painting from life demands.

Photographs lend themselves quite naturally to retinal painting. As with the eye, the camera translates everything it confronts into a flat system of colored shapes. There are no contour lines to separate objects from one another. Sometimes insufficient color contrast can result in visual ambiguity.

In *Tarmac with Jet* (fig. 6.33), Julia Jacquette has carefully interpreted a photo of a plane parked on a wet runway. Translating the image into oil paint, she culled the many shapes and tones of color from the photo and transferred them to the painting, giving them added clarity and emphasis.

6.33 Julia Jacquette, *Tarmac with Jet*, 2008, oil on canvas. Courtesy of the artist.

RATIONALE FOR ASSIGNMENT NINE

Retinal studies are not only beneficial to painters and illustrators, for whom they have direct applications. The process of rendering observed color is instructive to all visual artists. It fine-tunes color perception, to be sure, but also provides an education in the nature of vision and reveals the way ambient light affects color in three dimensions.

These studies require surprisingly little drawing skill. You can restrict yourself to recording only the dominant shapes in a visual field or, if you have more confidence, probe deeper into smaller shapes and finer color distinctions.

ASSIGNMENT 9: *Retinal Studies*

9A. Make a small retinal study of a photograph. Select a color photograph from a magazine or, even better, take your own and print it yourself digitally. The photo should be the same size as your painting, no more that 48 square inches (310 square cm). A technical tip: Simple images with some broad areas of flat color are preferable to those loaded with intricate detail.

An important rule of thumb in retinal painting (whether from life or a photo) is to paint only what you see, but not *everything* you see. The goal is to probe the image or subject for shapes of color and then to render their qualities as accurately as possible. Rough in the largest shapes until you have covered the whole picture plane. Then decide on a secondary level of visual detail and paint those smaller shapes within the larger ones. Finally, work down to the smallest shapes you can reasonably address. Remember, the truthful rendering of even the largest shapes will be satisfying in its integrity. It can be easier to accurately transcribe the shapes in a photograph if you turn it upside down while working with it.

This photograph of a simple still-life set up (fig. 6.34a) was the source of the retinal study in figure 6.34b. Notice the careful match of hue, value, and saturation in all the colors. Notice, too, the simplification of detail, particularly in the elimination of printing on the side of the coffee can.

The pie slice in figure 6.35 is a distillation of a magazine photo. The student has beautifully observed the subtle interplay of chromatic grays and muted colors. Again, she has eliminated detail but remained true to the qualities of the major shapes she observed.

Figure 6.36 is a simplified study of a city street in winter. The photograph contained chromatic grays exclusively, so this is a rendering of subtle temperature distinctions. The painting is very broad and truthfully captures the essential features of the image.

6.34a Photo by Jean Whelan.

6.34b Study by Jean Whelan.

6.35 Study by Vivien Hubert.

6.36 Study by Amy Lombardo.

9B. Make several retinal studies from life. These can be still lifes, landscapes, or portraits. Keep the image somewhat small; try not to exceed 48 square inches (310 square cm).

If you are relatively inexperienced with painting from life, you should start with small still-life setups. A few simple objects placed in a group on a table in front of you will give you all you need to begin this adventure. It can be helpful to make a viewfinder out of cardboard. The opening through which you will view your arrangement should have the same proportions as your painting. Thus, if your format is 7 x 9 inches (17.8 x 22.9 cm), your viewfinder's window might be 3 1/2 x 4 1/2 inches (8.9 x 11.4 cm).

The viewfinder will help you "flatten" the scene before you by letting you see just where shapes lie in relation to the edges of the rectangle. You can rough in the basic outlines very lightly with a pencil, but keep your outlines simple. Retinal painting is based on shape, not outline. Once you have made some very general linear notations, paint in the big shapes.

Figure 6.37 shows a good way to start a study. Large, simple shapes are loosely painted, but color is carefully matched (even at this early stage of the painting). This study stopped here. It may look unfinished, but it has a good deal of truth in it already.

Figure 6.38 is a little more refined, but you can see that the focus is still on color and shape. Figure 6.39 was made by an experienced painter whose brushwork is confident. It was done with no prior outlining.

The dramatic composition in figure 6.40, has strong diagonals and multiple shadows. Notice that the artist has broken the hammer down into several subshapes while deciding to leave the bottle as one blue silhouette.

6.37 Study by Denis Murphy. In the initial stages of a retinal painting the large shapes of color are painted in.

6.38 Retinal Study.

6.39 Study by Marc Handelman.

6.40 Study by Anna Schuleit.

Water Glass Studies

A wonderful exercise in retinal painting involves a single glass of water placed upon several sheets of colored paper (figs. 6.41–6.44). No matter what your level of painting skill is, you will find a productive challenge in rendering the color shapes you find there.

6.41 Study by Rachel Scherer.

6.42 Study by Kevin Ciminelli.

6.43 Study by Raymond Hughes.

6.44 Study by Erika Heilmann.

Other Subjects

A variation on the still life is the interior. At first, the subject may be overwhelming in its complexity because it can take in so many objects and introduces the problem of linear perspective. But, so long as you remember the credo "paint *only* what you see, but not *everything* you see," you will be able to construct the scene before you. Render the colors and shapes as they appear in your viewfinder and work from large shapes to small ones. If you are not so familiar with working from life, allow for a little looseness in the perspective.

Figure 6.45 is a good example of editing out unwanted detail. This is a "found composition," but the geometry of the walls and furniture holds it together. The image appears to be literally constructed of colored shapes.

Heads are difficult, mainly because we tend to get preoccupied with likeness. But if you can maintain a psychological distance from your subject, capturing the subtle shifts in the color of flesh can be a rewarding challenge. In the self-portrait shown in figure 6.46, the artist coolly observes and records the color shapes she finds in her own visage. She is not an experienced painter, and the brushwork is rough, but the integrity of her observation shines through.

Landscapes, urban or rural, can be conveniently painted through a windowpane (fig. 6.47). A good viewfinder can be easily made by applying masking tape directly to the glass pane. Again, the proportions should match those of your format.

6.45 Study by Joanne Rumsey.

6.46 Study by Lozana Rosenova.

6.47 Study by Nathalie Shepherd.

FREE STUDIES

The four free studies shown here explore ideas introduced in this chapter. The retinal study shown below (fig. 6.48) tackles the visual complexity of reflective materials.

In a transparency study (fig. 6.49), a student marries subtle illusionism with spare, elegant design.

The collage in figure 6.50 employs several color progressions as design elements, and the meticulously painted study in figure 6.51 organizes color to create the illusion of shifting light on a three-dimensional pattern.

6.48 Study by Christina Grosso: Retinal painting with reflective materials..

6.49 Study by Paul Lin: Delicate hue transitions.

6.50 Study by Molly Heron: Improvised design using progression.

6.51 Study by Alice Chung: Illusionistic pattern with subtle color shifts.

Color and the Move Toward Abstraction

The historical hierarchy that put drawing before color was overturned in the late 19th century by the French Impressionists. What followed that major innovation was revolutionary.

Painters throughout Europe began to work in a more direct and improvisational manner. Instead of following the academic tradition and building their images up from compositionally resolved underpaintings and then applying color in translucent glazes, artists like Van Gogh, Bonnard, Cézanne, Klimt, Munch, and Matisse integrated color and drawing to make the painting process nonhierarchical (fig. 6.52).

Once painting procedures became more fluid, a new awareness of the effect of process on both form and content arose. Artists began to regard the materiality of paint as an important part of the viewer's experience of the painting.

Artists experimented with the surface qualities of their pictures. Puvis de Chavannes lightened his color and gave his oil paintings a dry appearance that imitated the look of frescos. Vuillard explored matte surfaces by working with distemper, a paint made by grinding powered pigment into hide glue. Many others also gravitated toward nonreflective surfaces that gave their colors a forceful, declarative quality. Some, like Manet and Marquet, explored *alla prima* painting, a direct process in which the entire image is painted in one session: the perfect fusion of color and drawing.

In addition to this burgeoning interest in the physicality of painting, pictures became more conceptual over time and less reliant upon the idea of faithful transcription of nature.

Color, space, and standards of "finish" in painting underwent serious revision leading up to the 20th century. The final step toward a nonreferential and abstract art was, in fact, not such a large one. Kandinsky's early abstractions (fig. 6.53) were coloristically, spatially, and physically anticipated by the art of the previous three decades.

6.52 Henri Matisse, *Nature Morte aux Oranges (II)*, 1899, oil on canvas. Washington University Gallery of Art. Gift of Mr. and Mrs. Sydney M. Shoenberg, Jr., St Louis.

6.53 Vassily Kandinsky, *Red Oval*, 1920, oil on canvas. Solomon R. Guggenheim Museum, New York.

Richard Diebenkorn

The paintings of Richard Diebenkorn suggest the fundamental link between retinal painting and abstraction. Throughout his career, Diebenkorn alternated between representational and abstract painting styles. His pictorial images, made from direct observation, are essentially retinal in their approach, as in *Corner of Studio Sink* (fig. 6.54).

In his abstract work, such as *Ocean Park No. 120* (fig. 6.56), Diebenkorn explored a visual language that, despite lacking direct pictorial references, maintains a strong connection to his observational paintings. When working abstractly, he substituted geometric shapes for objects like sinks, tables, windows, and chairs.

The detail of *Corner of Studio Sink*, shown in figure 6.55, reveals a striking connection between the two paintings. In either idiom, Diebenkorn focused upon the character of mark, color nuance, shape, and proportional refinement.

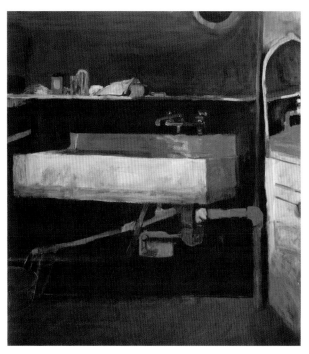

6.54 Richard Diebenkorn, *Corner of Studio Sink*, 1963, oil on canvas, Private Collection.

6.55 Detail of figure 6.54.

6.56 Richard Diebenkorn, *Ocean Park No. 120*, 1979, oil on canvas. Collection of Mr. and Mrs. Benjamin Frankel.

7. COLOR HARMONY

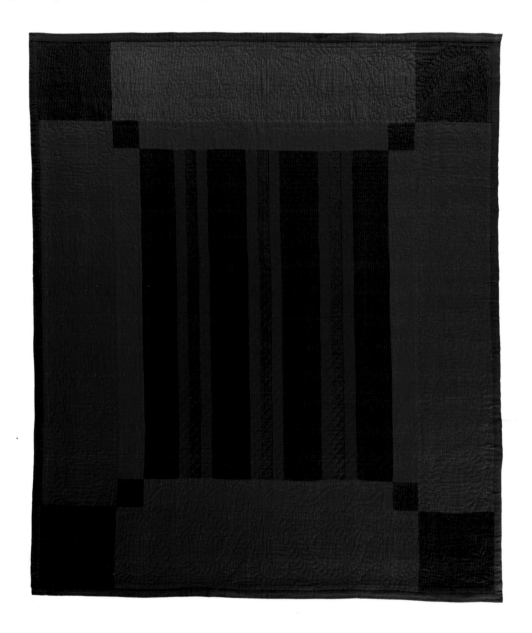

"The word 'art' means harmony for me. I never speak of mathematics and never bother with the Spirit. My only science is the choice of impressions that the light in the universe furnishes to my consciousness as an artisan, which I try, by imposing an Order, and Art, an appropriate representative life, to organize."

Robert Delaunay

COLOR HARMONY

The term "harmony" comes from music and refers to the relationship between musical tones that are heard simultaneously. In common parlance, the word means only concordance, or when things are in sympathy with each other. But, in music, harmony can be concordant or discordant, i.e. pitches heard together can blend seamlessly or provoke acoustical tension. In using the term to describe color relationships, we regard the full range of harmonic possibility, from concordance to discordance, as potentially useful. Visual tension is a necessary formal tool and color can contribute tension to art and design.

When we consider color relationships, it is important to transcend ideas we may have about fashion and good taste. It is more productive to think about the qualities of concordance (unity) and discordance (disunity) without passing a value judgment on either. An open understanding of COLOR HARMONY in its fullest sense will help you tailor your color effectively to its purpose in your work. There is no universal standard for "good color." Color relationships work when they match the purpose they are intended to serve.

When colors share visual qualities, we perceive them as interdependent or unified. Conversely, the less they have in common, the more they assert their independence and create a sense of disunity. Unity suggests tranquility and concordance. Disunity can, in varying degrees, evoke tension and discord.

Every hue in the color spectrum has its polar opposite or complement on the color wheel. The polarity of complements makes them stand in opposition to each other. When we discussed color interaction, we mentioned that the juxtaposition of two complementary colors sharpens their mutual distinctions.

In figure 7.1, a yellow-green is seen against a blue-green which is analogous to it. These two colors have much in common. They do not argue with each other and their qualities merge.

In figure 7.2, the same yellow-green is seen against its complement: red-violet. This combination emphasizes the differences between the two colors.

Saturation and value contrast are also factors in color harmony. In figure 7.3, a pale chromatic gray yellow square is set against its complement: violet. The resulting contrast in hue, value, and saturation is discordant.

When colors are closely matched in all three structural categories, they bind together. For example, two muted colors that are close in hue and value are juxtaposed to create a tightly unified visual field in figure 7.4.

We should recognize that neither unity nor disunity is intrinsically preferable; it depends entirely on the artist's or designer's goals. For example, the kind of disunity we see in figure 7.3, might be troublesome in a wallpaper design, but fit to purpose in a painting where disjointed color relationships can be psychologically significant.

7.1 Yellow-green seen against an analogous color: blue-green.

7.2 Yellow-green seen against its complement: red-violet.

7.3 High contrast in hue, value, and saturation makes for strong disunity.

7.4 Low contrast in hue, value, and saturation creates tight unity.

Unity and Contrast in Hue, Value, and Saturation

Some general observations can be made about the unity of color groupings based upon contrast in hue, value, or saturation. As mentioned, any group of colors that is similar in all three factors will be unified. Figure 7.5 shows such a group. All nine colors are red-violet, hover around the upper-middle part of the value scale, and are chromatic gray. The absence of contrast makes for cohesion. Try to imagine an application for such a concordant palette of colors.

7.5 A group of colors unified in hue, value, and saturation.

More energetic than our first example would be a group that shows contrast in one of the three color factors. Figure 7.6 is comprised of nine colors that are unified in value and saturation. The hues, however, are widely dispersed and come from all parts of the color wheel. The result is clearly livelier than in figure 7.5, but still holds together as a whole. No colors jump out.

7.6 A group of colors unified in value and saturation but showing contrast in hue.

A group united in all but value (fig. 7.7) also affords some visual incident but remains cohesive overall.

7.7 A group of colors unified in hue and saturation but showing contrast in value.

A color grouping that is unified in all but saturation (fig. 7.8) is perhaps a bit more subtle in its contrast than the previous two examples. The visual tension builds more slowly and asserts itself with a quiet insistence.

7.8 A group of colors unified in hue and value but showing contrast in saturation.

The next group (fig. 7.9) is unified in only one color factor: value. Discord in hue and saturation creates greater visual tension by several degrees than in all the previous examples. This combination has both unity and disunity but, in some parts of the grid, the visual tension is readily apparent.

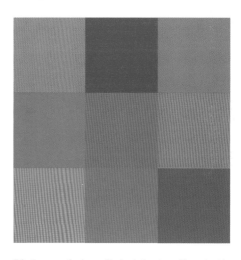

7.9 A group of colors unified only in value with contrast in both hue and saturation.

Finally, we have a combination of colors that are unlike in every category (fig. 7.10). This grouping is extremely uncohesive but may manifest less visual tension than the group shown in figure 7.9. A kind of boisterous vitality competes with a sensation of visual tension.

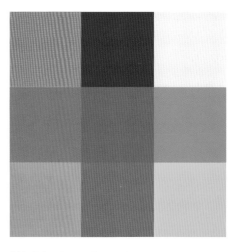

7.10 Colors that are disparate in hue, value, and saturation.

Color Proportion and Visual Harmony

So far we have discussed color harmony in terms of contrast. Another significant factor is proportion. Reconsider our block of nine disparate colors shown again here at right (fig. 7.11). In the grid format, all colors appear in the same quantity. What happens if we tinker with the proportions, making them less equal?

Figure 7.12 shows two arrangements of the same colors from the grid at right, but in uneven proportions. By altering proportion, we have placed greater emphasis on some colors and minimized the effect of others. At the same time we have broken free of the deadening stability of the grid.

In the variation at bottom left, blue and violet – close in hue, value, and saturation – form a harmonious backdrop accented by smaller increments of brighter and lighter colors. In this arrangement, yellow, yellow-green, and orange call out, but the impact of their contrast with the background is tempered by their relatively small size.

The design at bottom right is, again, based on the same colors in differing proportions. This time, however, the background juxtaposes two very different colors: a warm chromatic gray and a strident yellow-green. There is also a great deal of tension in the lower-right quarter of the design. The bright red square, which in the first design is seen against a sympathetic violet, rages here against a bright yellow-green background.

Using the same colors in different quantities and locations, these two variations show that proportion, contrast, and color location influence the harmonic disposition of color arrangements.

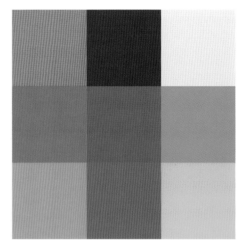

7.11 Nine disparate colors in equal proportions.

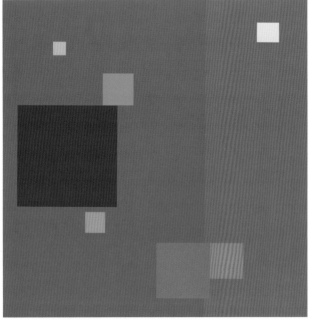
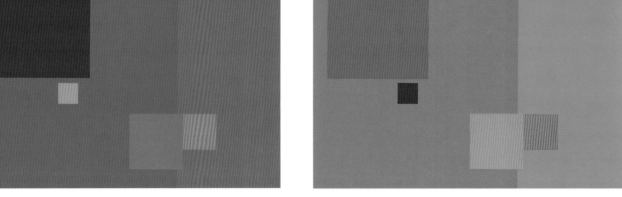

7.12 Two proportional variations of the colors shown in the grid in figure 7.11.

Bridge Tones

The contrast between two distinct colors can be mitigated by the presence of BRIDGE TONES. These are tones that contain elements of both colors. Bridge tones can be placed between or relatively near contrasting colors to make a visual transition and provide a measure of harmony.

In figure 7.13, a prismatic scarlet is paired with a muted blue-green of a much lighter value. They are quite distinct from each other in every respect.

In figure 7.14, the same two colors are separated by a sequence of three bridge tones that smooth the transition from the red to the blue-green.

7.13 Two opposing colors, differing in hue, value, and saturation.

7.14 The same two colors "bridged" by progressive tones.

The grid in figure 7.15 is composed of the original red and blue-green plus 14 bridge tones arranged alternately by hue as in a chessboard. Although there are points of contrast, the overall grouping is cohesive. The many bridge tones provide visual transitions that soften the contrast between the two original colors.

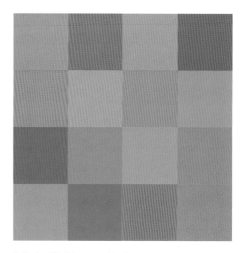

7.15 A grid of the two original colors with 14 bridge tones.

At right (fig. 7.16), the same tones have been arranged in a more progressive sequence, moving from reds and reddish tones at the bottom of the grid up to greenish tones in the upper half. With the bridge tones organized in this manner, the contrast between red and green has less visual impact.

7.16 The same colors organized as a progression.

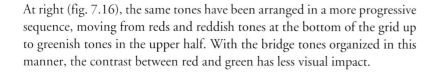

TWO MIXING STRATEGIES THAT PRODUCE UNIFIED COLOR

We are now going to experiment with two methods of generating a cohesive range of colors. The first is to produce tones through the intermixture of a limited palette, usually of no more than three colors. The second method is to set up a palette of colors and then mix an admixture (often an earth tone) into each one. This produces a group of concordant tones that can be applied in a design. These strategies can be productively employed in studio practice.

1. Intermixing a Limited Palette

A surprising range of tones can be produced from a palette consisting of two or three colors plus white, especially if the hues involved cover the extremes of the color spectrum. Intermixing complementary pairs, as in the example shown at right (fig. 7.17), can yield an array of colors.

Another good choice for a limited palette is the primary triad. Think about the primary colors in terms of specific pigments rather than simply red, yellow, and blue. For example, a triad of lemon yellow, scarlet, and sky blue will produce a different range of tonalities than will cadmium yellow deep, crimson, and ultramarine blue. The color overtones of each primary pigment shape the characteristic range of the resulting palette.

Consider the potential of cadmium yellow deep, crimson, and ultramarine blue in terms of value, hue, and saturation. Intermixing any primary triad (with white) will afford a full range of value from dark to light. Versions of every major hue are also available. But crimson is biased toward violet and cadmium yellow deep toward orange. This means that a prismatic orange would not be possible using this triad. Green is even more compromised since neither ultramarine blue nor cadmium yellow deep is biased toward green. Violets, on the other hand, are well served as both ultramarine blue and crimson are biased toward violet.

Earth tones can also be included in a primary triad. Imagine the effect yellow ocher might have in a triad with ultramarine blue and crimson. Or the entire triad could be comprised of earth tones (fig. 7.18). In that case, a broad range of values would be available, but the hue range would be more limited. In saturation, there would only be chromatic grays and dull muted colors.

7.17 A wide range of tones achieved through intermixing orange, blue, and white (shown at lower left).

7.18 Colors generated by intermixing a primary triad composed of earth tones.

RATIONALE FOR ASSIGNMENT TEN

Assignment 10 explores the possibilities of a simple palette comprised of two complementary colors plus white. This seemingly rudimentary color scheme can yield a rich array of unified tones. Pay attention to the consistent quality of light inherent in any combination of the colors you achieve. This assignment will help you appreciate the expressive potential of what one might suppose to be a stark limitation.

ASSIGNMENT 10: *The Two-Color Complementary Palette*

10A. Put down a pair of complementary colors on your palette plus a quantity of white. You can choose any two complementary colors including tertiary hues, e.g. red-violet and yellow-green. The two colors should be prismatic in saturation to begin with. Your format should not exceed 48 square inches (310 square cm).

You are about to make a "color dot inventory." This is a systematic exploration of a palette's range carried out by cross-mixing the colors on the palette. The dot inventory begins with a midtone background of the most neutral gray that you can mix by combining the two complementaries you have chosen for this study with white (fig. 7.19).

When you have established a background color, paint three penny-sized dots representing the two original complementary colors plus white at the top of your format. In our example (fig. 7.20), the two colors on the palette are ultramarine blue and orange.

The third step is to represent the range of possible colors this combination can yield by mixing 12 tones at three levels of value: low, midtone, and high value. Of course, infinite tones are possible, but this inventory is designed to give you an idea of the parameters inherent in your pair of complements.

Look at the tones in figure 7.21. With blue and orange, a wide range of dull greens and blue-green hues are obtainable along with numerous earth tones. Violet and its neighbors are difficult to achieve.

In terms of value and saturation, the story is different. Possible values range from almost black to almost white, and the full range of saturation is available as well.

Most importantly, all of the tones derived from intermixing this, or any, pair of complements share a quality of inherent light that makes them compatible with each other. A painting made directly from these complements will have a similar coloristic unity, as would a design using any number of these specific tones.

7.19 A mid-value, neutral background made by combining the selected complementary pair and white.

7.20 The same background with three dots repesenting a complementary pair, ultramarine blue and orange, plus white.

7.21 Tones derived from the complementary palette organized in groups of low, medium, and high value.

10B. Here you will apply tones from the dot inventory you made in Assignment 10A to create a simple design. On a format not exceeding 48 square inches (310 square cm), paint a background in a color that matches one of the 12 tones of the inventory (fig. 7.21).

Using at least nine tones taken directly from the inventory, make a collage as in figure 7.22. Include among your tones the original complements at full strength.

7.22 A collage using tones from the complementary dot inventory (fig. 7.21).

RATIONALE FOR ASSIGNMENT ELEVEN

Assignment 11 expands the lessons of Assignment 10. In two dot inventories you will explore the tonal range of two distinct primary triads with follow-up applications of these palettes. Again, the focus is on a unified inner light among a group of tones created by intermixing a small number of colors.

ASSIGNMENT 11: *Intermixed Dot Inventories*

11A. Choosing from the six co-primary colors in your paint box, put three primary colors plus white out on your palette. As with the previous dot inventory, establish a background color that is a neutral mid-value by intermixing the selected primaries with white. As before, paint dots at the top representing the three original colors on your palette plus white. Then, through intermixing, create three rows of six tones each. Each row should be at a different value level: mid-value, dark, and light. Try to make the hue range as broad as possible.

The dot inventory in figure 7.23 emanates from lemon yellow, cadmium red medium, and Prussian blue. Since lemon yellow is biased toward green, cadmium red medium toward orange, and Prussian blue toward green, you would expect vivid, highly saturated greens. Oranges are vivid but not prismatic, and violets are dull.

7.23 Tones derived from a primary triad of lemon yellow, cadmium red medium, and Prussian blue.

11B. Using a primary palette of earth tones (yellow ocher, burnt sienna, and a dull blue-gray), create a dot inventory following the same procedure as in Assignment 11A (fig. 7.24).

11C. Make two identical collages based upon the two primary triad dot inventories you have just made. Choose a minimum of 12 distinct tones from each inventory. Try to make the colors of the two studies match in hue and value as much as possible.

Examples:

The two examples shown below express the range of each palette. Figure 7.25 (based upon lemon yellow, cadmium red medium, and Prussian blue) gives access to a full range of saturation in the oranges. Greens are lively, but violets are constrained.

The earth-tone triad used in figure 7.26 produces a range of hues, and saturation levels are confined to muted colors and chromatic grays. The visual effect is subdued.

7.24 Tones derived from an earth-tone primary triad, organized in groups of low, medium, and high value.

7.25 Collage using 12 tones from figure 7.23.

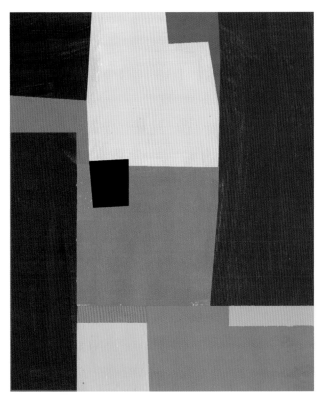

7.26 The same collage with tones from figure 7.24.

2. The Altered Palette

Another way to create cohesion among a group of diverse colors is by altering each color with a small amount of an "outside" color. Any group of disparate colors can be pulled together in this manner.

In figure 7.27, a group of six diverse, highly saturated colors on the left are each altered by the addition of a quantity of burnt umber. Earth tones, particularly umbers, are useful as unifying admixtures because they are low in saturation and therefore affect the saturation of the original colors somewhat equally. In fact, any chromatic gray will have a similarly consolidating effect.

Figure 7.28 shows the same group of six colors altered by a highly saturated blue-green. As you can see, this admixture has a more uneven effect on the resulting saturation levels. The blue-green dulls violet, red-violet, and red effectively, but does nothing to diminish the saturation of green or yellow to which it is closely related.

Proportion of Admixture

Of course, the proportion of the admixture will affect the saturation level of the resulting color. In figure 7.29, the green on the left has been mixed with increasing amounts of burnt sienna. Notice that the largest amount of admixture has produced a color of nebulous hue. Is it green or red? It depends on the context, as shown below in figure 7.30.

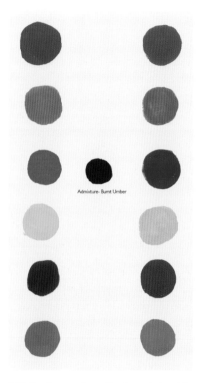

7.27 Six diverse colors unified through the addition of an earth-tone admixture (burnt umber).

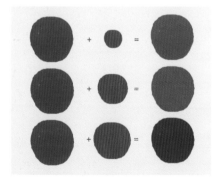

7.29 The effect of differing proportions of admixture on a color.

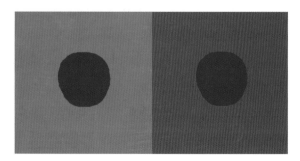

7.30 The third admixture from figure 7.29 might be either red or green.

7.28 The same six colors combined with a more saturated admixture.

RATIONALE FOR ASSIGNMENT TWELVE

In Assignments 12A, B, and C, you will explore the use of an admixture as a unifying color strategy. Pay careful attention to proportion – you want to alter the original color visibly, but just how much will require sensitivity to the entire palette. This is a useful approach for generating tonal cohesion among a range of disparate hues.

ASSIGNMENT 12: *Compositions with Color Admixtures*

12A. Create a color chart as in figure 7.27. Start with a stack of six diverse colors on the left. Then, on your palette, alter each color with an admixture of an earth tone or chromatic gray. Paint a second stack of the altered tones opposite your original colors on the right-hand side of your chart.

12B. Now, on a rectangle or square of no more that 48 square inches (310 square cm), create a simple design using the six raw colors on the *left-hand* side of your color chart. Use collage or a direct-painting technique.

12C. Recreate the same format using the altered colors on the *right-hand* side of your chart.

Examples:

The first example (fig. 7.31) answers the requirements of Assignment 12B. The six original colors from the chart (fig. 7.27) are arranged in a design. The colors clash and the effect is energetic if a little harsh.

The second version of the same design (fig. 7.32) illustrates Assignment 12C. Here the same hues that appear in figure 7.31 have been tempered by an admixture of burnt umber. The resulting colors are drawn together and the overall quality is more concordant.

Neither coloration is "good" or "bad" in and of itself. The efficacy of a color arrangement can only be assessed in view of an artist's intent. But it is obvious that the tempered colors are more unified than the initial group because they all have one color in common: burnt umber.

7.31 A simple design with six disparate hues taken from the left-hand side of figure 7.27.

7.32 The same design as above with an altered palette taken from the right-hand side of figure 7.27.

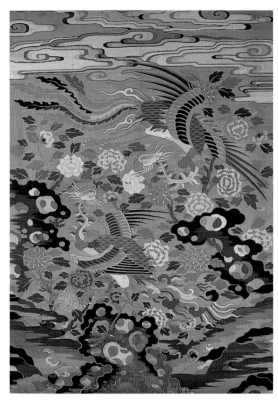

7.33 Maker unknown, *Feng Huang Panel*, Ming Dynasty, polychrome silk and gold. The Newark Museum, Newark, N.J.

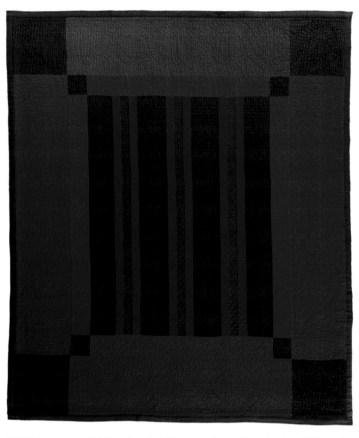

7.34 Maker unknown, *Split Bars Quilt*, Amish Lancaster County, Pennsylvania, c. 1930, wool and cotton. The Metropolitan Museum of Art, New York.

Four Examples of Color Harmony

The exquisite woven panel shown above (fig. 7.33) is based upon an opposition of two disparate hues: gold and blue. Within this limited palette are numerous variations of gold and blue that run the gamut in value from a deep, dark indigo to a light cream approaching white. Many subtle hue variations also bridge the gap between the two poles of the color scheme. Saturation contrast is kept minimal; all tones are either muted or chromatic gray. While there is plenty of energy here, the color is thoroughly unified.

The Amish quilt in figure 7.34 is a bit more tense. The overall darkness of the values holds the color together and creates a contemplative atmosphere. But there are areas of tension where the warm red interior border meets the cooler crimson surrounding it and the red "split bars" compress strips of blue-green. The simplicity of the geometric design allows the color choices to resonate with full power.

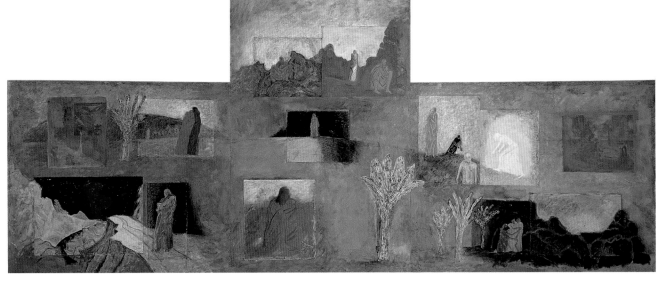

7.35 Mary Frank, *What Color Lament?*, 1991–93, acrylic and oil on board. Whitney Museum of American Art, New York.

Mary Frank's painting *What Color Lament?* consists of a series of pictorial episodes that function like collected memories. The color is episodic too. Most of it is tonal, shifting from chromatic gray to muted color within each vignette. The only prismatic colors are a yellow, which spreads out into a luminous tint, and an acidic scarlet. These brighter colors provide a tension that heightens the painting's evocation of introspection and loss.

Monument by Philip Guston is characteristic of his late work wherein he applied virtuosic paint handling and idiosyncratic style to an exploration of existential themes. Here, it is likely that the only colors on his palette were cadmium red, ultramarine blue, and either black or burnt umber (plus white). Every tone in the painting is generated by cross-mixing those few colors. Nevertheless, the picture is suffused with light and space. The color's cohesion lends a naturalistic aspect to a comical but strangely disturbing image.

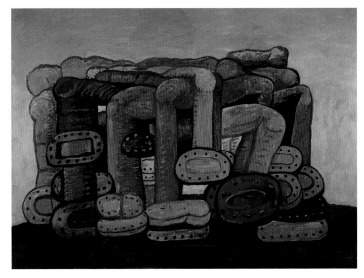

7.36 Philip Guston, *Monument*, 1976, oil on canvas. Tate, London.

FREE STUDIES

The free studies shown on these pages all engage the issue of color harmony as introduced in Part Seven. Think of them in terms of color concordance and discordance. Consider how these students have employed concepts such as color contrast, bridge tones, proportion, and location in their color choices.

7.37 Study by Nicholas Felton.

7.38 Study by Tory Etlinger.

7.39 Study by Samantha Mendez.

7.40 Study by Danielle Galvin.

7.41 Study by Nicole Cassano.

7.42 Study by Richard Martinez.

8. COLOR RESEARCH

"Color exists in itself, possesses its own beauty. It was Japanese prints that we bought for a few *sous* on the rue de Seine that revealed this to us."

Henri Matisse

SOURCES OF COLOR

A good colorist cultivates a taste for discovery in his everyday encounters with the richness of the visual environment. Both natural phenomena and cultural artifacts offer myriad examples of exquisite color and color arrangements. The most common things, e.g. seashells, stones, leaves, paper wrappers, faded wallpaper, old book covers, peeling paint, or green leaves against a roiling gray sky, can provide color inspiration. Paintings, prints, weavings, quilts, and posters, are also a good source for color ideas. Anything that attracts you can provide a stimulus for original work.

All artists can fall into routine and need refreshment from outside sources. Henri Matisse, for example, made a lifelong study of color in the decorative arts of Eastern cultures. Paul Klee collected and studied the paintings of children and Vincent van Gogh spent evenings by lamplight arranging bits of colored yarn on a gray piece of cardboard in order to experience, outside of painting, the optical effects of color created by fragments upon each other.

The contemporary British painter Howard Hodgkin has been a serious collector of Indian miniatures. His own work is noted for its color and there is little doubt that Hodgkin's study of Indian art informed the development of his style. Shown below is a miniature from the 17th century and one of Hodgkin's own paintings (figs. 8.1 and 8.2).

You too can begin to identify natural or manmade objects that attract and inspire you. Collect those things that intrigue you and, when you can't own them, photograph or scan them. Peruse art books, catalogues, and magazines for delectable examples of color relationships. Make a scrapbook of what you find and dip into it for nourishment whenever you feel the need.

8.1 Basohli (India), *The Lonely Drishna Explains His Plight*, c. 1660–70, gouache. Victoria and Albert Museum, London.

8.2 Howard Hodgkin, *The Green Château*, 1976–80, oil on wood.

ASSESSING COLOR CONTENT

A good way to assess the color in an image or object you admire is to make an inventory of it. We have devised two approaches to color inventory: proportional and nonproportional.

The Proportional Color Inventory

A PROPORTIONAL COLOR INVENTORY represents the colors found in a source in a way that also depicts their proportional distribution. This approach is best suited to images that have a somewhat graphic appearance with areas of flat color. Woodcuts, wallpaper designs, many examples of Eastern art, package design, and modern paintings done in a graphic style, e.g. Picasso's synthetic Cubist paintings or Miró's Surrealist abstractions, all lend themselves to proportional color analysis. Bear in mind that even graphic work, like Japanese woodcuts, may contain areas of subtle gradation that require some "rounding-off" to a single tone. Images with innumerable tones, like a painting by Vermeer or a color photograph, can be approached in this way as well, but a careful interpretation is necessary to simplify the many tonalities in these images to a discrete group of no more than 20 colors.

The most efficient way to organize a proportional inventory is with stripes arranged in a rectangle. A vertical or horizontal rectangle of any proportion will do. Color can be applied directly (using removable tape to create sharp edges) or glued in place as in a collage.

The painting shown below by Žaneta Zubkova (fig. 8.3) is a good candidate for a proportional inventory. Most of the colors are relatively flat and their proportions can be easily summarized. In making the inventory, we estimate color proportions to the best of our ability (see fig. 8.4).

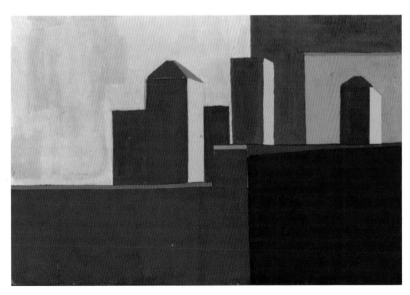

8.3 Žaneta Zubkova, *Moment*, 2008, gouache. Courtesy of the Artist.

8.4 Proportional inventory of figure 8.3.

RATIONALE FOR ASSIGNMENT THIRTEEN

Assignment 13 introduces the proportional inventory. The selection of an image should be carefully considered and reflect your personal color affinities. Breaking down such an image into a proportional diagram extracts the color content and makes it more accessible for use. The studies derived from your source give you an opportunity to apply, in a personal way, what you have gleaned from it.

ASSIGNMENT 13: *A Proportional Inventory with Design Studies*

13A. Make a proportional inventory of any image. As mentioned before, graphic images such as printed textiles, woodcuts or any picture with some flat colors are preferred. As you can see in the Choki woodcut we have chosen as an example (figs. 8.5 and 8.6), even a graphic image requires some interpretation where the color is not quite flat. Try to estimate the precise proportions of the color in your image. Paint directly or use a collage technique with painted paper.

13B. Make a simple design using the colors from your inventory with the same proportions as those found in the source image (fig. 8.7). The study should not exceed 48 square inches (310 square cm) and can be done with direct painting or by using a collage technique.

13C. Make a second, related study using the same colors but in different proportions (fig. 8.8).

8.5 Eishosai Choki, *Hunting Fireflies*, 1785–1805, woodcut. Musée des Arts Asiatiques-Guimet, Paris.

8.6 Proportional inventory of figure 8.5.

8.7 Design derived from proportional color inventory of figure 8.5 using the same proportions.

8.8 Design derived from color inventory of figure 8.5 using different proportions.

The Nonproportional Color Inventory

Natural and manufactured objects that have innumerable colors can be complex, but they can still provide color inspiration. To assess their color content in a proportional color stripe inventory is difficult; there are just too many colors. Instead, we can make a NONPROPORTIONAL COLOR INVENTORY to address these complex visual phenomena.

In a nonproportional inventory, the goal is not to record every color we see, but to summarize what we see with a limited number of tones that represent the colors and their range. Here, as in the complementary and triadic inventories of the last chapter, the colored dot serves as an expedient format.

Nonproportional inventories can be surprising. When you begin to extract specific colors from a complex color field, you will discover that they take on an unanticipated strength and singularity. It is a great way to produce a useful palette that carries you beyond your habitual color choices.

Natural objects, in particular, tend to yield groups of colors that cohere beautifully. Whether used exclusively or as the foundation for improvised additional colors, a palette derived from the nonproportional inventory can be a taproot into unfamiliar color terrain and expand your color sensibility.

Figure 8.9 shows a typical color source and figure 8.10 is a nonproportional inventory derived from it. Since no sampling can include all the colors in the leaf, the same object might yield several different inventories.

8.9 Color source: a leaf.

8.10 Nonproportional inventory of figure 8.9.

RATIONALE FOR ASSIGNMENT FOURTEEN

Assignment 14 provides a second strategy for the evaluation of color in a chosen object. The nonproportional color inventory is particularly suited to visual phenomena that are too coloristically complex to assess proportionally. The follow-up study provides an opportunity to apply the colors of the inventory to an original design (figs. 8.11–8.13).

ASSIGNMENT 14: *A Nonproportional Inventory with Design Study*

14A. Begin the inventory with a flat background color taken directly from the object under scrutiny. (Color photographs of objects can also be used as a source.) Decide upon which colors best characterize the object. Try to represent the range of hues, values, and saturation levels you find. The number of dots is up to you, but the fewer the dots, the coarser your summary of the color will be. Somewhere between 8 and 14 dots is usually a good number.

14B. Make a simple design using the colors from your inventory. The study should not exceed 48 square inches (310 square cm) and can be done with direct painting or using a collage technique.

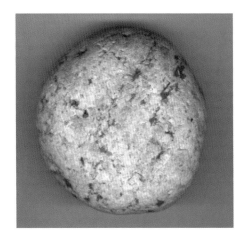

8.11 Color source: a stone.

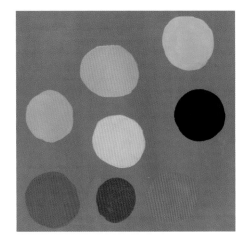

8.12 Nonproportional inventory of figure 8.11.

8.13 Study by Caroline Macfarlane derived from nonproportional inventory of figure 8.11.

Variations on the nonproportional color inventory can be explored in free studies. Using a shell as a source (fig. 8.14), this student made a nonproportional color inventory (fig. 8.15). But when she created the woven paper study below (fig. 8.16) she applied her color more loosely than in the assignment, brushing the gouache on thinly and letting the paper show through in places to expand the tonal range of the colors. This more informal approach shows how one can adapt this strategy (and others we have explored) to personal use.

8.15 Nonproportional inventory of figure 8.14.

8.14 Color source: a shell.

8.16 Study by Christine Adolph derived from nonproportional inventory of figure 8.14.

DESCRIBING COLOR

"I also have the portrait of a girl of 12, brown eyes, black hair and eyebrows, yellowish matte complexion. She sits in a cane chair, a blood-red and violet striped jacket, a deep blue skirt with orange dots, a branch of oleander in her hand. The background light green, almost white." Vincent van Gogh wrote this description of the painting shown at right (fig. 8.17) to his sister Willemien on July 31, 1888.

The letters of Van Gogh are rich with careful attempts to describe the color of his paintings or the color of those subjects that inspired him. He mentions hue, of course, but also uses specifying adjectives that suggest value ("light green") or saturation ("deep blue"). He reaches for analogy in the term "blood-red" and refers to surface luster when alluding to a "yellowish matte complexion." The frequency of such color description in Van Gogh's letters confirms the importance he accorded color in his work.

8.17 Vincent van Gogh, *La Mousmé*, 1888, oil on canvas, National Gallery of Art, Washington, D.C., Chester Dale Collection.

Despite the limitations of language, the descriptive analysis of color in works of art can help sharpen your powers of observation and fortify your understanding of color structure. Truly, we tend to look more closely when we are compelled to describe something. Any colorful art object from any historical period or geographical location can provide an opportunity for verbal analysis.

In your descriptions, use the terminology and concepts you have encountered here, e.g., color key, tint, shade, prismatic, muted color, chromatic gray, hue, value, color temperature, and saturation. Think about the color structure in the work you are examining along with other related factors, e.g. how the disposition of the color works to assert or deny the illusion of space. Try to assess how color specifically contributes to the overall experience of the piece.

Group critiques provide an excellent venue for careful description. In fact, describing what we see lays a solid groundwork for more interpretive comments, tying form and content to the meaning and experience of a work of art.

FOUR COLOR DESCRIPTIONS

This lively little painting by Aida Fry (fig. 8.18) places a light-struck figure painted in muted colors and chromatic grays against a flat, prismatic red background. This sets up a spatial contradiction – the insistent red pushing the softly modeled forms of the head and shoulders forward. But although there is spatial tension, the figure is painted in tones of orange and violet, both of which contain red. The pervasiveness of red throughout the painting, both explicit and implicit, holds the tension in check.

8.18 Aida Fry, *Small Head Study*, 2011, gouache on paper. Courtesy of the artist.

Pierre Bonnard was a great French painter and colorist who constructed his pictures out of many small touches of color. Unlike the Impressionists, whose method was similar but who depicted reflected light as they observed it, Bonnard imagined the light in his paintings.

The Garden (fig. 8.19), painted in 1936, exemplifies his mature style. Contrast abounds in hue, value, and saturation, but if you squint at this image, you will see that the color has been massed into flat shapes that fit together like the pieces of a puzzle. These shapes are defined by either a dominant value (as in the small dark tree at the painting's center), or by hue (as in the softly defined green triangle that floats directly above it).

Each shape in the painting is comprised of many small and precisely mixed fragments of color that contribute particles of inflection to the color of the whole shape. Bonnard is quite willing to let the contours of plants and animals shimmer. His images rely on optical mixing. They crackle with an internal, flickering light achieved through numerous shifts of temperature in zones of similar value. In this welter of shape and color, the subject comes into view gradually – as if we have come blinking into daylight.

8.19 Pierre Bonnard, *The Garden*, c. 1936, oil on canvas. Musée d'Art Moderne de la Ville de Paris, Paris.

The work of Diane Itter was a protracted investigation of color and pattern. She produced hundreds of knotted textiles on an intimate scale.

Grid Flicker #1 (fig. 8.20), is broad in hue, value, and saturation, but Itter's controlled evocation of multidirectional light provides coherence. She deployed color progressions to create a sense of light and movement.

The grid structure seems to be suspended in front of a shifting field of background illumination. Yet in places where it becomes lighter in value, it also appears to be lit from the front.

Itter constructed the piece so that the strands of linen seem to pour out of the bottom of the design. This outflow of color mitigates the hardness of the grid. Each particle of color is a knot, so the color is fused through optical mixing.

8.20 Diane Itter, *Grid Flicker #1*, 1981, knotted linen. Private collection.

This refined colored pencil drawing by Constance Simon (fig. 8.21) uses color in a minimal way. The hue is monochromatic, confined to tones of red-orange. Saturation is constrained to muted colors and chromatic grays. Only value is broadly represented, with a highly controlled account of value nuance. But, despite its restraint, the drawing has a luminous and colorful aspect. The inherent light in Simon's subtle oranges bathes the entire image in a rich glow. At the top of the wishbone she brings the color trapped in the flat bone tip up, not just in value but also in saturation, to create a point of exquisite illumination.

8.21 Constance Simon, *Wishbone*, 1999, colored pencil.

FREE STUDIES

8.23 Study by Sharyn Adler Gitalis. This study, made by intermixing an earth-tone triad, demonstrates how that strategy plays out in a painterly context. In a few strokes, the artist has summoned up earth and air with mist rising on golden hills.

8.22 Study by Lorraine Greey. Despite the overall darkness of this image, there is a hierarchy of contrast in value and hue that lends it variety and interest. The strongest note is the small prismatic red rectangle in the lower left-hand corner.

8.24 Study by Matthew Palen. Here, analogous hues revolve around yellow-orange. This study is painted over a dark, greenish-brown background that peeks through wherever the top layer has been separated by brushstrokes made with a stiff hog's-hair brush. The soft grid structure is echoed by softly glowing colors.

8.25 Study by Isaac Tobin. Here the artist has intermingled fragments of printed matter with color applied through a rudimentary stamping technique.

8.26 Study by Janice Linsay. Based on *Portrait of a Yellow Man* by Paul Klee, this study explores color in a series of shifting planes. The most saturated color, yellow, is located behind several earth tones to create a sense of spatial compression at the center.

8.27 Study by Gregory Ricci. This whimsical study suggests a tinker-toy interpretation of a classic "vanitas" still life complete with skull. The hue range is broad, with the complements yellow and violet dominant. There is also great contrast in value and saturation. You can almost hear the painting go clankity-clank.

8.28 Study by Lise Perreault. The four trianglar shapes in the center of this design seem to read as a pyramid seen from above, one plane struck directly by light. But, at the edges, the facets of the form slip away and flatten out. Line and color are integrated to tease the viewer into a contradictory spatial interpretation.

8.29 Study by Rosamund Kavander. The color in this design came from intermixing a primary triad of ultramarine blue, naphthol crimson, and yellow deep. Its energy is due to strong color contrasts and a sense of spontaneity.

9. COLOR EXPERIENCE AND INTERPRETATION

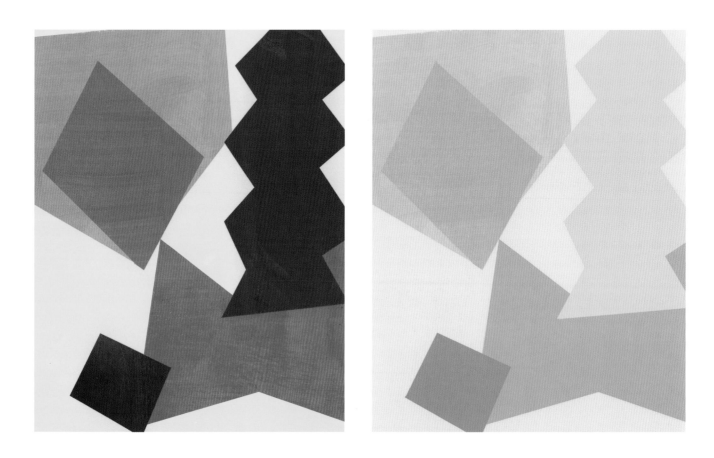

"Pure colors... have in themselves, independently of the objects they serve to express, a significant action on the feelings of those who look at them."

Henri Matisse

COLOR: SYMBOL AND ANALOGY

So far, we have discussed color primarily as a visual phenomenon. We have addressed its structure, its interactive nature, and the character of its interrelationships. But color has an added dimension that is as essential as its optical behavior and structural parts: That is, the way it stimulates the heart and mind of the viewer. No account of its application in art and design can ignore this fundamental aspect of color experience. But, intrinsic as it is, our psychological response to color is unquantifiable and tends to evade objective understanding.

Although color has a psychological impact upon us, it can be highly idiosyncratic, especially when it comes to personal color preferences and associations. Indeed, those preferences and associations may evolve over the lifetime of a single individual. Aspects of color experience are also bound by culture to some extent, and can be specific to a particular location or era. Therefore, generalities about what colors signify or how certain colors make us feel should be viewed with a degree of uncertainty.

With that caveat in mind, we will examine the two primary modes of color "meaning": symbolism and analogy.

Color Symbolism

When a color is used to signify an abstract idea or represent a belief, it functions as a symbol. Sometimes the meanings attached to a color can differ or even be contradictory. The color blue, for example, can signify loyalty as in "true blue," or melancholy (the "blues"). Red can mean loss of profit ("in the red") or indicate illicit sexual activity (the "Scarlet Letter"). Purple can signify royalty, but also dramatic excess as in "purple prose."

Some of these associations are literary but are rooted in observation. For example, the European term "blue blood" for aristocracy may originate with the fair skin of the upper class who, because of their social status, weren't exposed to the darkening effects of the sun, making their blue veins more readily visible than those of the lower classes.

Whatever the precise origins of such associations, this kind of COLOR SYMBOLISM is generally not the result of a spontaneous psychological response to observed color, but rather a learned connection bound by time and place. In the West, for example, yellow can signify cowardice. In 14th-century Japan, however, warriors wore a yellow chrysanthemum as a pledge of their courage.

Color symbolism is almost always based upon pure hues as seen on the spectrum and typically involves a single color. There are, however, several examples of simple color combinations that have symbolic meanings. Certain holidays in North America are associated with symbolic color pairs: red and green with Christmas, orange and black with Halloween, and purple and yellow with Easter. Tricolor combinations linked with nationality are usually derived from flag designs.

Color symbolism, while it can convey meaning, is a very limited tool because symbolic meaning is prefabricated. Its conventionality also invites cliché. In the hands of a clever artist, however, color symbolism can be invested with irony to create new meanings by recontextualizing old ones.

One such artist is Barbara Kruger. Kruger creates large-scale works that juxtapose text and photography to comment upon contemporary cultural attitudes. Her designs have an artless but forceful quality that imparts a sense of urgency to her wry insight.

The color in Kruger's work, usually red and black, is strongly redolent of the propaganda poster art of both the Nazis and Bolshevists. But instead of proclaiming, "The Reich will never be destroyed if you are united and loyal," Kruger's text is usually more oblique, e.g. "How dare you not be me?" or "I shop therefore I am" (fig. 9.1). She employs the commonly understood historical connection of red and black with unequivocal political propaganda to make critical points about social hypocrisy, consumerism, and gender politics. She is a subversive artist who makes ironic use of the visual tropes of authoritarian rule to criticize the status quo.

Color Analogues

There are certain hues and hue relationships commonly associated with specific psychological responses that seem more intuitively based than the symbolic color interpretations we have been discussing. Unlike color symbolism, analogy is not experienced as a literary phenomenon, but as the direct result of observation. In these instances, colors, which are strictly visual, are unconsciously interpreted as analogues for other, sometimes nonvisual experiences. They are felt, not thought. A good example of this is the warm/cool dichotomy represented in the bifurcated color wheel.

The equation of blue, green, and violet with coolness probably has its roots in our long-standing elemental relationship with ice, shadows, and deep water. Cool colors can provoke a sense of distance or exposure to the elements and even suggest solitude or indifference.

Conversely, linking red, orange, and yellow with warmth reflects our historic relationship with fire, the sun, and the desert. Warm colors also suggest body heat, which in turn can evoke associations with intimacy, anger, or sexuality. Most people seem to equate warm hues with emotion and cool hues with reason.

9.1 Barbara Kruger, *Untitled (I Shop Therefore I Am)*, 1987, photograph. Mary Boone Gallery, New York.

When we speak of warm and cool colors, we take only hue into account. Color analogy can also be experienced in terms of value and saturation. Figures 9.2 and 9.3 are both red and of the same value; they differ significantly only in saturation. Let's try some comparative associations. If these two colors were sounds, which would seem louder? If they were tastes, which would be sweeter? If they were temperaments, which more resolute? If ages, which more youthful? The answer to all four questions is likely to be the prismatic red (fig. 9.2) due to its relative brightness and clarity.

Value also carries a bundle of common associations. Dark colors appear to have more visual weight than light colors. If we associate musical pitch with value, we tend to connect colors at the lighter end of the value scale with higher pitch: a squeak would be very light in value, a thud much darker.

Associations that connect the visual properties of color with nonvisual phenomena seem to make a kind of intuitive sense, but one should be wary of trying to predict a viewer's response. For one thing, colors in art and design are seldom seen in isolation. When combined with other colors, their individual characteristics become subsumed into a larger whole that has a cumulative visual identity and provokes a more complicated reaction. Moreover, color is only one of the elements that go into making a work of art. It is normally integrated with other formal variables, e.g. shape, interval, relative scale, line, graphic style, and type. The complexity that results from the interrelatedness of all visual factors in an image can make it difficult to separate the psychological impact of color from that of the whole.

The painting *Dangerous* by David Frazer (fig. 9.4) has a complex visual vocabulary that combines two different styles of representation with energetic brushwork that courts painterly accident but, paradoxically, in a highly controlled way. The tulips appear to be printed or stenciled but, in fact, were painted directly. These procedural ironies are manifest in the whole image, which is an oil painting that has some of the visual qualities of a collage.

Color is the quietest aspect of the painting. It is strongly unified and holds Frazer's stylistic and procedural contradictions together. The palette is comprised of earth tones and muted colors that we would find in nature; you could call it a naturalistic palette. Indeed, the color has a kind of sumptuous beauty that we associate with Dutch still-life painting of the 17th century. The tulips, of course, help prompt that association, but the abruptness of the pictorial juxtapositions in this image opposes the familiar comforts of its color.

9.2 A prismatic red.

9.3 A duller version of the same red.

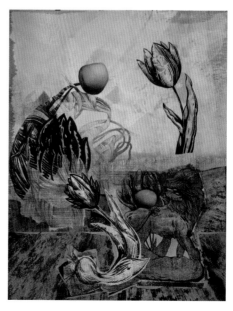

9.4 David Frazer, *Dangerous*, oil on paper. Private Collection.

The Psychological Effect of Color Relationships

Just as individual colors are linked, through analogy, to our worldly experience, the composite quality of color groupings can also provoke associations. The overall effect of a color group is influenced by the choice of hues, but perhaps more important is the quality of contrast in hue, value, and saturation. To illustrate this, we will examine a series of grids each consisting of nine colors. The grid format allows us to isolate the effect of color relationships without the distraction of other formal variables.

The first grid (fig. 9.5) consists of nine prismatic colors of diverse hue and broad contrast in value. The color relationships are not subtle. Instead, they possess a joyful energy. This kind of palette is often associated with the art work of children or with folk art.

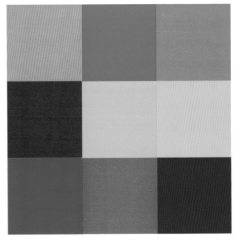

9.5 A bright group of hues that evokes gaiety. This kind of color group is often associated with children.

The second grid (fig. 9.6) uses the same hue arrangement, with the value relationships also preserved, but this time an admixture of raw umber and white has been added to each color. This alteration makes for a much quieter ensemble of tones. In relation to figure 9.5, the colors look a bit dusty and timeworn. They may evoke a sense of age.

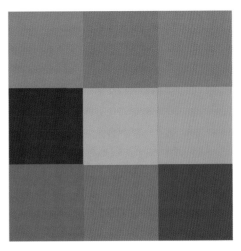

9.6 The same hue arrangement as in figure 9.5, but with an admixture of raw umber and white.

The grid in figure 9.7 uses the same hue arrangement again. This time the admixture is white alone and the result is a collection of highly luminous tints. Compared to the previous two examples, this group is light and airy.

9.7 Another version of the same hues highly tinted.

Mark Rothko and some of his contemporaries, such as Ad Reinhardt and Barnett Newman, simplified other formal variables in order to put color up front. All three eschewed any kind of conventional illusionistic space so that color might locate itself freely within the picture plane to assert both its literal and visual location based, as strictly as possible, upon color temperature and relative saturation. They understated the physicality of the painting as well, applying the paint flatly and with no brushstroke and no sheen. In *No. 64* (fig. 9.8), the dominant visual experience is that of color. A few simple, soft-edged rectangles mark the colors' parameters and assert the flatness of the picture plane. The closeness of the values and subtle distinctions of the reds and browns make for a slowly revealing and contemplative visual experience.

Color is used in print advertising to make a product look appealing in a way that is consistent with its purpose, which is to help tell a story. The ad shown in figure 9.9 promotes the delights of a red wine whose flavor suggests the rich fruitiness of plums and blackberries accented with "a hint of toasted oak." The deep violets of the peeled plums emerge from dark shadow and are met at the center by the warm yellows and browns of the fruit's seeds and flesh.

At lower right (fig. 9.10) another ad sells specially designed baby cups. The children are a multicultural group and the shifting backgrounds, in bright muted colors, reinforce the theme of diversity. That the background colors are close in value and the faces arranged in a grid strikes a note of equality. The overall effect of the color is pleasantly warm and intimate. The color of the ad and its content are perfectly synchronized.

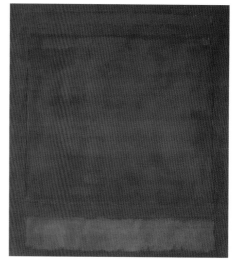

9.8 Mark Rothko, *No. 64*, 1960, oil on card. Collection of Kate Rothko Prizel. Rothko gave color the greatest importance in his work by underplaying the effect of other formal variables.

9.9 Ad for wine.

9.10 Multicultural ad for baby cups.

RATIONALE FOR ASSIGNMENT FIFTEEN

By painting the same design twice in two very distinct color "moods," you will experience the difference color can make to the psychological effect of a design or work of art.

ASSIGNMENT 15: *A Design in Two Moods*

15A. Invent a simple linear design that has a distinct mood of its own. Using painted paper collage or a direct painting technique, apply color that you believe is in sympathy with the character of the design. If the design is aggressive, make the color aggressive, and so on.

15B. Make a second version with the same design but use color that seems to express a different mood. These studies should not exceed 48 square inches (310 square cm).

Examples:

Figure 9.11 shows a linear design that could be characterized as "forceful." All edges are diagonal and there are several points of visual tension. The overall effect is relatively energetic.

The first color version of this design (fig. 9.12) is composed of six colors that contrast strongly in hue, value, and saturation. These contrasts heighten the boldness of the design and complement its expressive character.

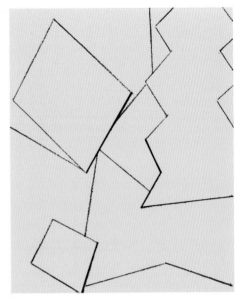

9.11 A "forceful" or "aggressive" linear design.

9.12 A forceful design with emphatic color.

The second version of this design (fig. 9.13) is more passive. The brightest colors in figure 9.12 have been replaced with much duller and quieter versions of the same hues.

9.13 A forceful design with passive color.

In the painting shown at right (fig. 9.14), William Itter has fragmented natural and architectural forms to create an animated visual tapestry that embodies his diverse visual interests among which are quilts, weavings, folk art, Cubism, and the spatial conundrums of Escher and Piranesi. The palette, on the other hand, is simple: Warm and cool chromatic grays prompt a flinty evocation of rock and soil and are cunningly orchestrated to provide contrast wherever it is needed. The color is applied in luminous progressions of value and temperature within larger shapes. This is an excellent example of stabilizing a highly complex image with a constrained palette.

9.14 William Itter, *Axis I: Home at Four Corners*, 1997, oil on canvas. Indiana University Art Museum, Bloomington, Indiana.

COLOR IN THREE DIMENSIONS

This course of study focuses on the use of color in flatwork, but it would be an oversight not to discuss, in a general way at least, the application of color in three dimensions.

Three-dimensional color applications extend beyond making discrete objects, of course. They also include architecture, landscape architecture, interior design, and theatrical set design. In these disciplines, color can literally engulf the viewer through lighting, shadow, texture, pattern, and the reflective properties of various materials. There is much to say about such environmental color pursuits that would be of interest. This discussion, however, would take us too far afield. Therefore, we will confine our examination of color in three dimensions to its use in sculpture.

A painting or design can be well or badly illuminated, but any alterations in its appearance will be due primarily to the quantity of light and its temperature. Its formal relationships, which are largely visual rather than physical in a sculptural sense, are unaffected by changes in the direction of the light source. (The exception is a strong raking light that can render a picture's surface irregularities starkly visible.)

In contrast, when making three-dimensional art and design, the problem of lighting and its effect upon the legibility of form is a central issue. Pale, smooth surfaces like marble, plaster, and light colored woods express sculptural form more clearly than dark materials do. A sculptural object can change in appearance dramatically with alterations in the quantity of light and its angle. It is also subject to the effects of reflected light. Sculpture that is placed outdoors, for example, will pick up color from surrounding grass, trees, or stones. Its general appearance will also be altered in accordance with changing weather conditions or the time of day.

Color can be applied to almost any sculptural object with paints, stains, or, if made of clay, ceramic glazes. It can also be colored by other, less traditional processes which include chemical reactions, burning, surface abrasion, and the application of industrial colorants.

As a category, sculpture is far more diverse than painting. Today, it still includes traditional media, e.g., clay, wood, stone, plaster, and metal, as well as a range of industrial materials and processes that have expanded sculpture's physical possibilities considerably. The term "sculpture", however, is also applied to installation art, earth art, conceptual art, video art, and digitally conceived and generated three-dimensional forms. Color is frequently an aspect of contemporary sculpture in all of its manifestations.

Applied Color

When color is applied to a fully realized form, there is a risk of perceptual conflict. Object-makers who employ color usually take into consideration the way in which color can compete with form.

Polychromed sculpture occurs throughout human history and goes back as far as ancient Egypt. The example at right (fig. 9.15) is a 20th-century piece from the Yaka people of central Africa. Contrasts in color help differentiate the parts of the figures and make them stand out from the background with greater emphasis.

When applying color to a completed form, sculptors often consider surface texture. Is it matte and powdery or does it have a sheen? The color too can have tactile properties that either agree or disagree with those of the underlying object. It can seem to sit on top of the surface or, as in a stain, settle into it; it may also be opaque or translucent.

Grace Wapner applies paint to her ceramic sculptures. The soft, matte quality of her surface treatment is compatible with the surface of fired clay. She applies the paint judiciously, leaving much of the clay untouched. Her use of color helps assert a visual hierarchy and adds an additional level of visual information to the piece while supporting its essential form (fig. 9.16).

Occasionally color is used to confound the perception of three-dimentional form. For example, in *Norris Ring* (fig. 9.17), Frank Stella uses it deliberately to obscure both the relative spatial positioning and the precise contours of his planar forms.

9.15 Yaka People, *Board*, 20th century, carved polychromed wood. Museum of Central Africa, Tervuren, Belgium.

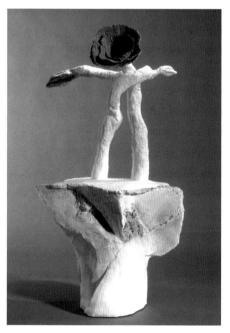

9.16 Grace Wapner, *Scholar's Garden VI*, 2002, stained and painted ceramic. Private Collection.

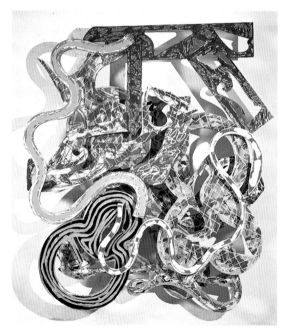

9.17 Frank Stella, *Norris Ring*, 1982, mixed media on etched aluminum. Stella Collection.

Intrinsic Color

A sculptor needn't apply color to make it an important part of his work. The intrinsic pigmentation of materials can contribute color and even pattern to sculptural form.

In *Sharp and Flat* (fig. 9.18), Martin Puryear uses the inherent dark knots and streaks of reddish grain in pinewood to mitigate the sculpture's hard contours. The color variations wrap around the entire piece and animate its form.

Found objects that have endured the effects of time are often beautiful because their original color has been seasoned by the stress of physical existence.

No artist has employed the beauty of timeworn materials more sensitively than Joseph Cornell. His assemblages put the subtle color shifts and surface wear of found objects to a highly personal poetic use (fig. 9.19).

9.18 Martin Puryear, *Sharp and Flat*, 1987, pine planking. Private Collection.

9.19 Joseph Cornell, *Soap Bubble Set*, 1945, mixed media. Private Collection.

Color as a Material

Sometimes color itself can be at the core of a sculptural experience. Anish Kapoor creates powdered pigment sculptures, letting the pigment flow out on to the surrounding floor to create the visual impression of a form composed of solid pigment. The surface is densely non-reflective and the color has a disarmingly pure quality (fig. 9.20).

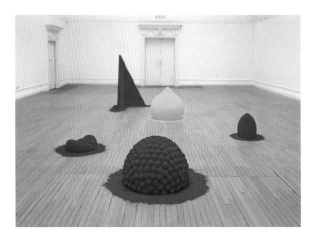

9.20 Anish Kapoor, *To Reflect an Intimate Part of the Red*, 1981, mixed media and pigment. Lisson Gallery, London.

In work that combines sculpture and photography, Erin O'Keefe makes color the central issue (fig. 9.21). She constructs small-scale interiors with colored walls, then carefully illuminates and photographs them in a way that accentuates the mystery of color and light.

9.21 Erin O'Keefe, *Grey/Pink/Gold God Light*, 2011, archival pigment print. Collection of the Artist.

Sometimes artists use actual light as color in their art. Keith Sonnier often incorporates neon tubes into his three-dimensional work. The piece shown here is entitled *Faya* (fig. 9.22) and demonstrates how tubes of light can become a sculptural element while, at the same time, illuminating the work. Other artists, e.g. James Turrell and Olafur Eliasson, use both artificial and natural light as pure color on a grand scale.

9.22 Keith Sonnier, *Faya: Oldowan Series*, 2009, neon, satin, gauze/steel, and transformer. Courtesy of Mary Boone Gallery.

10. COLOR STUDIES ON THE COMPUTER

"To attend to color, then, is, in part, to attend to the limits of language. It is to try to imagine, often through the medium of language, what a world without language might be like."

David Batchelor

THE COMPUTER AS A STUDIO TOOL

Most contemporary artists and designers rely on the computer to some extent, depending on the nature of their creative practice. They may make work outright in digital form, or augment traditional processes with digital means. Because photography and text layout have been digitized through software like Adobe Photoshop and InDesign, even artists who don't use the computer in production, use it in the documentation and promotion of their work. Whatever their involvement with the computer, artists today tend to think of it as a natural extension of their studio toolbox, as essential to their practice as an easel, drawing table, or loom.

The two artists whose work is shown below (figs. 10.1 and 10.2) make digital prints. Each also makes work in other media. Mark Johnson is a painter and printmaker who, in addition to working digitally, continues to make images using traditional printmaking techniques, e.g. aquatint and etching. His digital and traditional works are closely related and each constitutes a facet of his creative sensibility.

Carson Fox uses the computer not just to create prints, but also for research and visualization when planning larger two- and three-dimensional projects. She is a multimedia artist who has a broad range of technical skills that includes digital technology.

10.1 Mark Johnson, *Dark Matter*, 2009, digital print. Courtesy of the Artist.

10.2 Carson Fox, *Foolish Love*, 2008, manipulated giclée print with hand-hole-punching. Courtesy of the Artist.

Michael James makes fine-art studio quilts. In recent years he has been using the camera and computer to create textile designs that he prints digitally on fabric and then constructs into large-scale wall pieces. His work often combines abstract elements with his own photographic imagery that he processes in Photoshop. In *The Idea of Matter* (fig. 10.3), James integrates scanned images of translucent leaves with a series of small rounded shapes derived from photographs he took of evaporating lozenges of water encountered while walking on a brick pavement in Seoul.

COLOR STUDIES ON THE COMPUTER

The ubiquity of the computer is a fact of contemporary art and design. Digitally conceived and produced work has become commonplace, seen everywhere alongside work in other new and traditional media. But, like any technology, it has limitations as well as special advantages.

This course of study is predicated on the importance of a physical involvement with color. "Building color" with paint on paper and placing it in an interactive context under ambient light fully engages both sight and touch. One gains a bodily understanding that becomes almost unconscious and bridges the gap between theory and practice.

Despite its usefulness as an addendum to the color pedagogy presented in this book, digital studies cannot take the place of working in reflected light with real materials. Some may argue this point, but consider the fundamental fact that, in a sense, the computer screen presents color with a light behind it. Unlike colors that we see by virtue of reflected light, colors on the screen appear disembodied, as if in a vacuum. Moreover, when you stare into a "backlit" color for a length of time; your eyes lose some of their ability to discern fine distinctions due to visual fatigue. While not so extreme, it is a bit like staring into a light bulb.

Nevertheless, by the mid-1990s it had become clear that the computer could be of great value in reinforcing lessons learned with paint and paper. When students followed up on handmade assignments with digital versions, they strengthened their grasp of color concepts and developed skills that enabled them to transfer those concepts into the digital realm.

This chapter of the book is meant to serve as a guide to redoing digitally the color studies you have already made by hand. It covers some of the basic elements of color as organized in both Adobe Photoshop and Illustrator, and discusses the use of sliders to create and adjust specific colors.

If you don't have access to the software or printing facilities, don't worry: Computer studies are not essential to this course. But if you can revisit on the computer the color concepts you have already learned, you will find a parallel universe within which you can fortify your understanding.

10.3 Michael James, *The Idea of Matter*, 2010, cotton and dyes, machine-pieced and machine-quilted. Private Collection.

Software and Output

Although you can make most of your color studies in either Adobe Photoshop or Illustrator, the program best suited to creating precise color relationships is Adobe Illustrator. It has features that make it perfect for interaction and progression studies in particular. Chief among these is that in Illustrator color changes can be viewed within an image at the same time as the sliders are adjusted.*

Whether working in Illustrator or Photoshop, make your designs as simply and directly as possible. Our goal in this course is not to master the software, or dazzle ourselves with elaborate, heavily layered designs, but rather to use digital means simply, to echo the assignments we have already done on paper and reflect upon the basic color principles that they illustrate.

To output your studies, use an inkjet printer and matte heavyweight paper. The paper is 11 x 8 1/2 inches (29.9 x 21.6 cm.). Use the same size guidelines that we used in the painted studies – make 48 square inches (310 square cm) your outside limit, to save you money in ink costs. And in the interests of thrift, make very small "thumbnail" prints of your designs as you work on them before committing to a full-size print.

* Real-time color changes in Photoshop can be experienced only while working in one of the mask modes, available in the "Adjustments" palette: "Selective Color," "Hue/ Saturation," or "Color Balance." These adjustments produce global changes to the digital image, i.e. they change the hue, value, or saturation of a particular color in all areas of the image containing that color. This can be useful when altering colors in photographic images. When creating digital designs for the assignments in this course, however, Illustrator provides better control for color selection and the manipulation of individual shapes or areas in a design.

RGB and CMYK

In digital programs, two different sets of primary colors come into play: RGB (red, green, and blue) and CMYK (cyan, magenta, yellow, and black). These two distinct systems represent the two modes of color application: light and pigment.

Red, green, and blue are the primary colors familiar to lighting designers. The color theory that underlies the manipulation of light is called additive. Because screen images appear in direct, rather than reflective light, the colors we see there are made additively by combining red, blue, and green light.

If you are only familiar with mixing pigments, you may find creating color in RGB mode somewhat counterintuitive. In additive color mixing, red plus green makes yellow (fig. 10.4). Moreover, when colored lights are combined, the color at the overlap is more luminous than the two colors that are its parents. The combination of all three primaries at full strength produces a white light.

The CMYK mode on the computer monitor is designed to simulate subtractive color mixing and represents the primary triad we know from mixing pigment. Figure 10.5 shows how the subtractive primaries form a secondary triad when intermixed. The combination of all three colors at the center is a dark chromatic gray, not black. Black, or "K tone," is added to make a true black possible and to expand the range of tonal possibilities.

Digital output, i.e. a printed version of a digital document, is made with the subtractive primaries. Printing processes use translucent inks instead of paint. In four-color and inkjet printing, cyan, magenta, and yellow (plus black) are overlapped and juxtaposed in tiny fragments for the eye to mix optically into what appear to be continuous tones.

The range of colors visually available in any system is called a GAMUT. The largest gamut is that of the colors we observe in the real world. Colors on a computer monitor are, in all modes, more limited in number than those in the visible spectrum.

The diagram at bottom right (fig. 10.6) shows the range of three color gamuts. The largest area, underlying the two linear configurations, is the visible spectrum. The second largest, represented by a pink triangle, is the RGB gamut. The smallest area, bound by a yellow line, is the CMYK gamut. Because the RGB gamut exceeds that of CMYK, there are colors that can appear on the computer monitor that will not be reproducible in printed form. (Adobe programs give a warning sign – ! – when a color created in RGB mode falls outside the CMYK gamut.) Bear in mind that colors appear more vivid on a monitor than they do in print. Also, subtle color relationships are more perceptible in print than they are on the computer screen.

10.4 In additive color, the overlapping of the three primary colors (RGB) produces a white light.

10.5 In subtractive color, the mixture of the three primary colors (CMY or blue, red, and yellow) produces a dark chromatic gray.

10.6 An illustration of three color gamuts. The visible spectrum is represented by the large, solid shape, RGB by the pink triangle, and CMYK by the area bound in yellow.

CREATING COLORS WITH SLIDERS

In both Illustrator and Photoshop, as in other programs, you have the option of working in RGB or CMYK modes. Choose CMYK. Your color training is with subtractive color and the CMYK sliders allow you to create colors in a way that mimics the mixing of pigments. Combining magenta (red) with cyan (blue), for example, will make violet. Also, as with paint, the addition of black (K) to any hue will make a shade of that hue.

Pushing sliders is, however, a somewhat abstract activity compared to the sensual experience of moving paint with a brush. Also, when using sliders, a few color functions are idiosyncratic. For example, on the monitor, colors are "tinted" not by adding white, but by moving the sliders to the left. The effect is similar to a mixed tint – a color becomes both lighter and duller – but the reasoning is different. Actually, the subtle and not-so-subtle differences you will encounter between mixing color by hand and making color on the computer will force you to process the structure of color in a fresh way. Students who follow up hand-made assignments with digital versions of those assignments strengthen their grasp of color principles.

Regarding Sliders in Terms of Hue, Value, and Saturation

Hue

In CMYK, as with pigments, the only one-part colors are the primaries. All other hues are made by combining two or three of the primary colors.

Value

With any color, changes in value are determined by moving sliders to the left or right: Move to the left to lighten and to the right to darken a color. If you move all sliders involved in a color simultaneously to precisely the same degree, you will alter its value without changing its hue.

Saturation

In working digitally, continue to think of saturation on three levels: prismatic color, muted color, and chromatic gray. The numbers that appear in the boxes to the right of the sliders indicate the saturation level of the color on each slider. (The exception is black, where the numbers indicate relative value, not saturation; black has no saturation.)

When using a single slider – say, cyan – moving the slider to the right will do two things: gradually darken the value of the color and strengthen its saturation. When you have pushed the slider all the way to the right, 100% of the saturation of that color is achieved.

With two-part colors (not considering black a color), the same holds true. Moving the two sliders to the right will increase the color's saturation.

Three-part colors are more complex. A third part, if it is pushed far enough to the right, will diminish the saturation level of the composite color.

Looking at Sliders

The following diagrams are a visual approximation of the color sliders you will find in most design software. It is useful, when using sliders, to maintain a structural understanding of the colors you are creating, i.e., to think of them in terms of hue, value, and saturation.

The first diagram (fig. 10.7) shows a one-part hue (cyan) at 100% saturation. This blue is prismatic. Even though we think of the prismatic level of saturation as being absolute, on the computer screen a color may appear prismatic as far down as 90% of its full saturation. Remember that the monitor registers the subtraction of saturation only coarsely and colors look more vivid there than they do in print.

Try this experiment. Start with 100% cyan on the slider, then, while looking at the color box on the slider, move the cursor slowly to the left. Try to ascertain just where the saturation shifts discernibly to the level of a muted color. The best way to make a true comparison is to create colored squares of cyan at 100%, 90%, and 80% and place them in a row with their edges touching. You will see a noticeable depreciation of saturation. (Of course, against a bright orange background, an 80% cyan will look like and, for all practical purposes, be a prismatic color.)

In figure 10.8, we see a "tint" of cyan at 50%. This is a muted color. Moving the slider to the left is like adding white: The value lightens, but the hue remains stable. In one-part hues (cyan, magenta, and yellow), only tints of pure color can be achieved. For example, it is impossible to make a midtone or dark chromatic gray with one slider.

An even weaker version of cyan is shown in figure 10.9. At 15% this is a chromatic gray. Familiarize yourself with the logic of the sliders through observation and experimentation. You will develop a sense of where the dividing line between chromatic gray and muted color should be.

Colors made of two parts (again, excluding black) are essentially the same as one-part colors. They can be tinted, but, at their darkest, they will be prismatic. (A two-part color can be fully saturated with neither color at 100%.) Like one-part colors, they cannot produce a midtone chromatic gray.

Three-part colors differ from one- or two-part colors in some important respects. Theoretically speaking, they cannot be prismatic,* and it is only with three-part colors that one can achieve chromatic grays at all value levels without resorting to black.

In figure 10.10, cyan, magenta, and yellow are lined up at 50%. You might expect the exact balance of the three primaries to make a temperature-neutral, achromatic gray. Actually, the color you get is a warm chromatic gray, akin to raw umber.

* Although a color with 80% cyan, 80% magenta, and 5% yellow will appear prismatic, it is only because the yellow, present in such a small proportion, has little discernible effect on the color. While it is numerically present, the yellow may not be visually so, especially on the monitor. In fact, a side-by-side comparison of this color with a two-part color of 80% cyan and 80% magenta reveals a disparity in saturation.

10.7 Cyan (a one-part hue) at full saturation: the prismatic version of this hue.

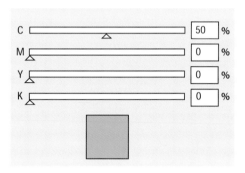

10.8 Cyan, "tinted with white," at 50% saturation: a muted color.

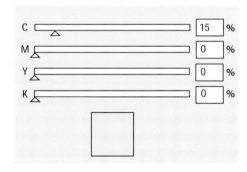

10.9 Cyan at 15% saturation: a chromatic gray.

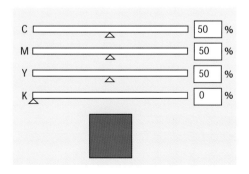

10.10 A three-part color with all colors lined up at 50% saturation. This makes a warm chromatic gray.

With three colors, it is easy to make chromatic grays and muted colors by starting with all three arrows aligned vertically. Then, simply pull the hues you want to emphasize away from the vertical alignment.

In figure 10.11, cyan, magenta, and yellow are aligned at 10%. This makes a warm chromatic gray that is very light in value. The hue and saturation are the same here as in figure 10.10; only the value has changed.

In figure 10.12, magenta and yellow are lined up at 40%, but cyan is pulled up to 60%. This has a cooling effect on the color, making it a bluish, dark chromatic gray.

Finally, in figure 10.13, a three-part muted color has been made of the chromatic gray from figure 10.12 by diminishing the quantity of magenta and yellow to 20% and maintaining cyan at 60%.

Using the Black Slider

The K tone or black slider makes it easy to darken and dull colors – simply move it to the right. Used alone, it produces achromatic grays in all values. Unlike black pigment, the addition of K tone to digital color has no deleterious effect on the inherent light of the resulting "shade." But for the sake of conceptual consistency, when making digital studies, try to limit your use of the black slider to 10% in any color you create. This constraint will make the exercises more rewarding.

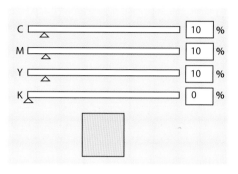

10.11 A three-part color with all colors lined up at 10% saturation: a pale, warm chromatic gray.

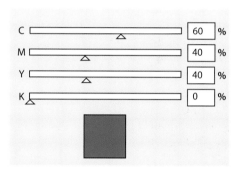

10.12 A three-part color with magenta and yellow at 40% saturation and cyan at 60% to make a cool chromatic gray.

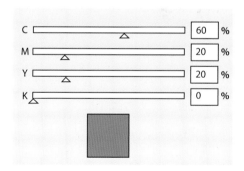

10.13 Diminishing the quantity of magenta and yellow while maintaining 60% blue transforms the chromatic gray in figure 10.12 to a three-part muted color.

Creating a Color Reference Chart

Printing your color projects on an inkjet printer can be frustrating. The color on the screen will always be at odds with your printed color. But there are degrees of difference that are tolerable and those that are not. In order to have a frame of reference for color transitions from screen to print, it is a good idea to make a color chart like the one shown on the opposite page (fig. 10.14). This chart will give you an overview of how colors of differing proportions print on your printer and give you some idea of how the color assignments you make on screen will look when you print them.

Take a look at how the grid of colors is organized. The primary and secondary hues (cyan, violet, magenta, orange, yellow, and green) are stacked in rows of columns. Each column has its original prismatic color at the top and, moving south, each color undergoes a series of transitions in tandem with its lateral neighbors. Rows two and three are "tinted" versions of the original color: Colors in row two are muted colors and, in row three, chromatic grays.

Rows four, five, and six are three-part colors. Row four is close to row three in value, but the addition of the third hue makes these tones a little dustier, not quite as saturated as those in row three.

Row five matches row two for value but, again, the added third color brings the saturation level down.

Row six consists of rich and relatively dark muted color variations of the originals.

You might also invent your own way of organizing your color grid. The main thing is to be systematic in your layout and try to encompass a broad range of chromatic possibilities. With practice, you will be able to look at a printed color and guess, with surprising accuracy, its numerical content.

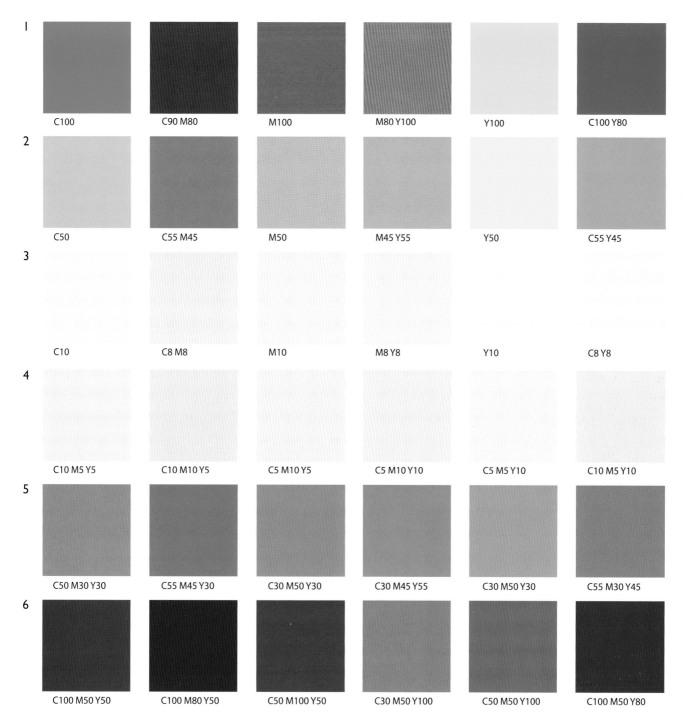

1 C100 C90 M80 M100 M80 Y100 Y100 C100 Y80

2 C50 C55 M45 M50 M45 Y55 Y50 C55 Y45

3 C10 C8 M8 M10 M8 Y8 Y10 C8 Y8

4 C10 M5 Y5 C10 M10 Y5 C5 M10 Y5 C5 M10 Y10 C5 M5 Y10 C10 M5 Y10

5 C50 M30 Y30 C55 M45 Y30 C30 M50 Y30 C30 M45 Y55 C30 M50 Y30 C55 M30 Y45

6 C100 M50 Y50 C100 M80 Y50 C50 M100 Y50 C30 M50 Y100 C50 M50 Y100 C100 M50 Y80

10.14 Color chart designed to help match screen color with the output of a personal printer.

REMAKING COLOR STUDIES DIGITALLY

Not counting free studies, there are 15 assignments in the earlier part of this course. Many of them are rewarding to revisit in digital form. Four assignments, however, cannot be made on the computer or are not worth doing digitally from a pedagogical standpoint. These are the retinal studies (Assignment 9), the painted dot inventories (Assignments 10 and 11), and admixture studies (Assignment 12).

On the following pages we will look at digital versions of the other 11 assignments. (When revisiting the assignments, you should find new solutions; do not simply recreate the studies you made with paint and paper.)

While making your digital designs, you will find it helpful to hide the bounding lines that surround shapes when they are highlighted so that you can observe the interaction between colors without interference from them. If you are working in Adobe Illustrator, you can do this by selecting "Hide Edges" and "Hide Bounding Box" from the "View" menu. In Photoshop you will have to uncheck the "Show Transform Controls" box contained in the options bar for the "Move" tool.

ASSIGNMENT 1: *Chromatic Gray Studies (page 50)*

This group of studies (Assignments 1–4) is based on closely related designs. As with the original assignment, you have the option of using identical formats for each variation.

10.15 Assignment 1A: Create a design entirely in chromatic grays with a broad hue range and broad value range.

10.16 Assignment 1B: Create a design entirely in chromatic grays with a broad hue range and narrow value range.

ASSIGNMENT 2: *Muted Color Studies (page 52)*

10.17 Assignment 2A: Create a design entirely in muted colors with a broad hue range and broad value range.

10.18 Assignment 2B: Create a design entirely in muted colors with a broad hue range and narrow value range.

ASSIGNMENT 3: *Prismatic Color Studies (page 54)*

10.19 Assignment 3A: Create a design entirely in prismatic color with a broad hue range and broad value range.

10.20 Assignment 3B: Create a design entirely in prismatic color with a broad hue range and narrow value range.

ASSIGNMENT 4: *Combined Saturation Studies (page 55)*

10.21 Assignment 4A: Create a design using all levels of saturation with a broad hue range and broad value range.

10.22 Assignment 4B: Create a design using all levels of saturation with a broad hue range and narrow value range.

Assignments 1–4 are the foundational studies for this course. They establish the fundamental vocabulary that we use throughout the course and foster an understanding of the essential tripartite structure of color. As you create these studies with sliders on the computer, you will get a sense of the interrelatedness of hue, value, and saturation in color manipulation. Print all computer studies and compare them to your painted ones.

ASSIGNMENT 5: *Color Interaction Studies (page 67)*

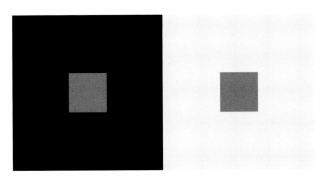
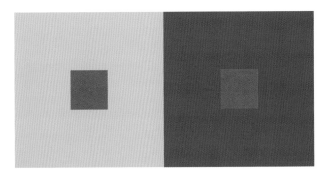

10.23 Assignment 5A: Make one color appear as two different values, first in achromatic grays and then with full color.

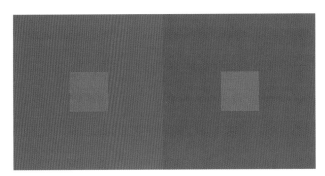
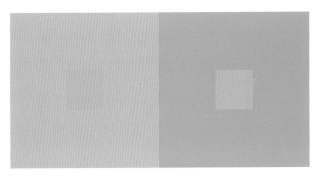

10.24 Assignment 5B: Make one color appear as two, predominantly in hue.

10.25 Assignment 5C: Make one color appear as two, predominantly in saturation.

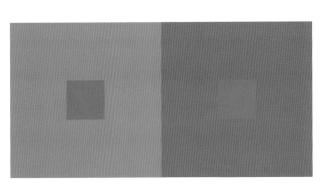
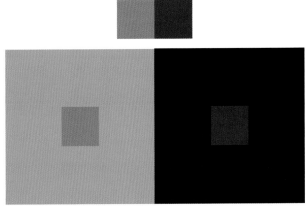

10.26 Assignment 5D: Make one color appear as two in hue, value, and saturation.

10.27 Assignment 5E: Make two colors appear as one.

ASSIGNMENT 6: *Interaction Composition (page 71)*

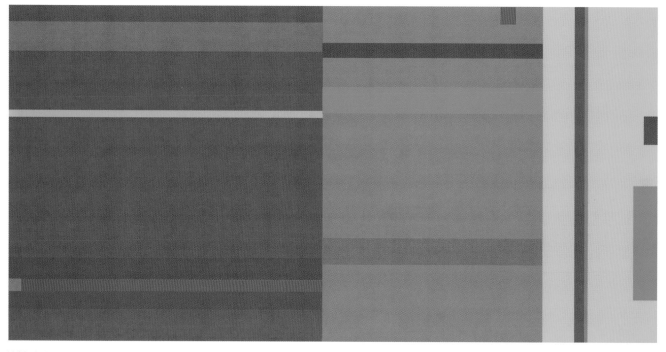

10.28 Assignment 6: Using a minimum of six colors twice, create a design that demonstrates the contextual nature of color identity.

Interaction studies done in Illustrator are highly instructive when you hide the bounding lines and see colors change *in situ* as you move the sliders to adjust them. You can clearly observe the effect minute modifications of the sliders have upon a color and its neighbors.

When composing your design for Assignment 6, keep it simple. Digital software facilitates visual complexity, but try to make this design no more complicated than your hand-painted studies. Keep in mind that its purpose is to illustrate concisely the color principle at hand.

ASSIGNMENT 7: *Color Progression Studies (page 80)*

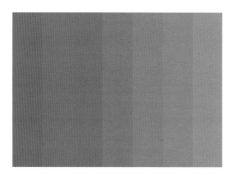

10.29 Assignment 7A: Compose two different color progressions and then intermingle them to create a visual synthesis of the two.

Progression studies fine-tune your sense of color relationships. Because the tonal transitions are so precise and visually linked, progressions yield a lucid sense of inherent light within each color.

As with Assignment 6, the composition in Assignment 7B should be simple (see example in figure 10.30).

10.30 Assignment 7B: Create a progression composition.

ASSIGNMENT 8: *Color Space Study (page 83)*

8A. Create a composition that consistently asserts the illusion of space. Use the rudimentary spatial indicators of overlapping shape and size variation to establish a spatial hierarchy in your design. Applying what you know about the effect of color temperature and saturation on pictorial space, use color in a way that agrees with the spatial order you have established in your shape arrangement.

8B. Using the same design and the same colors, reorder hue and saturation to make them contradict the logic of overlapping shapes and relative size.

10.31 Assignment 8A: Color consistent with size and position of shapes.

10.32 Assignment 8B: Color contradictory of the spatial order of size and shape.

ASSIGNMENT 13: *A Proportional Inventory with Design Studies (page 113)*

13A. Make a proportional inventory of any image (images with flat colors are preferred).

In the Adobe software you can use the "Eyedropper Tool" to extract precise colors. Make sure your "Swatches" palette is turned on from the "Window" menu. Then you can drag the extracted colors into the palette and build up your color inventory as a customized swatch library. This can be a useful tool for quick and easy access to these exact colors later on when making your own designs.

13B. Make a simple design using the colors from your inventory with the same proportions as those found in the source image.

13C. Make a second study using the same colors but in different proportions.

10.33 Source image.

10.34 Proportional color inventory from figure 10.33.

10.35 Assignment 13A: Design using the colors from figure 10.33 with original proportions.

10.36 Assignment 13B: Design using the colors from figure 10.33 in different proportions.

ASSIGNMENT 14: *A Nonproportional Color Inventory (page 115)*

14A. Choose a source image or object that has uncountable colors and make a nonproportional inventory that summarizes its chromatic content in a few colors. The background color should be part of the inventory. Once again, you can create an easily accessible digital inventory of your colors by dragging the extracted colors into the "Swatches" palette.

14B. Make a simple design using the colors from your inventory.

10.37 Source image.

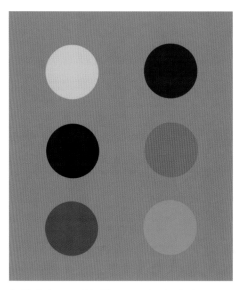

10.38 Assignment 14A: Nonproportional color inventory of figure 10.37.

10.39 Assignment 14B: Design derived from the nonproportional color inventory in figure 10.38.

ASSIGNMENT 15: *A Design in Two Moods (page 128)*

15A. Invent a simple design whose color and configuration evoke a distinct mood.

15B. Make a second version using the same design but with color that you feel expresses a different mood.

10.40 Assignment 15A: Design with a quiet mood.

10.41 Assignment 15B: The same design with a more raucous mood.

REALIZING YOUR COLOR POTENTIAL

Having done both the hand-made and digital follow-up studies outlined in this book, your grasp of color composition, behavior, and, most importantly, potential is now quite developed. The door is open to a broader application of color principles.

The internet offers several excellent sites that can connect you with an expanding color community online where you can find and contribute ideas and inspiration for color palettes and where colors are organized by HEX color codes* and RGB values.

Whether you make things by hand or in a digital format, color plays a profound role in contemporary art and design. An effective colorist relies on understanding, but also on a strong personal sense of color relationships that encompasses both aesthetics and meaning. In participating in this course, you have greatly increased your understanding, but to develop your personal color "vision" requires continued practice and mindful engagement. It is a lifelong studio discipline.

* HEX color codes, or hexadecimal color codes, are used by web designers to specify colors on the web. HEX codes begin with a hash (#).

ILLUSTRATED GLOSSARY

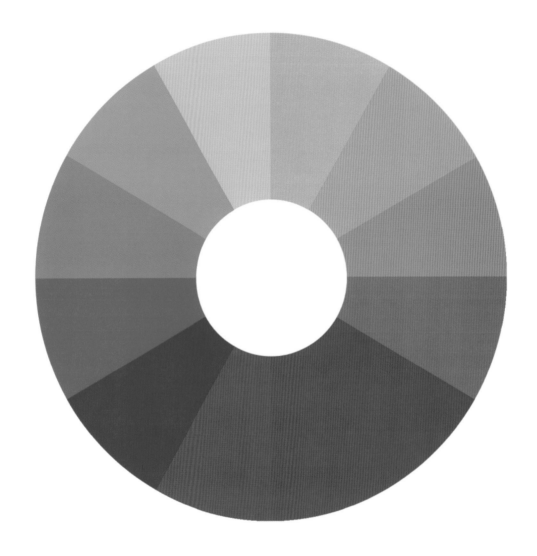

ACHROMATIC GRAYS

Achromatic means "without color". The term applies to black, white, and grays made by combining black and white. Achromatic grays, like black and white, have no hue and no saturation: only value.

ADDITIVE COLOR

Color seen as light: additive color primaries are red, green, and blue. When they are combined the result is white light.

AFTERIMAGE

A common optical effect in which an additional color seems to appear at the edge of an observed color. When a color is placed against an achromatic background, its afterimage will be the color's complement.

ANALOGOUS

Analogous hues lie adjacent to each other on the spectrum.

BRIDGE TONES

Bridge tones provide a transition between disparate colors. In the example on the right, the stark difference between a prismatic red at one end and a chromatic gray-green at the other is softened by a sequence of bridge tones that contain properties of both the red and the green.

CHROMATIC DARKS

These are dark chromatic grays that have discernible temperature and hue.

CHROMATIC GRAYS

Chromatic grays have relatively low saturation but still have discernible hue and temperature.

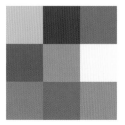

COLOR HARMONY

Color harmony is the character of the interrelationships in a group of colors. As with musical harmonies, color harmonies can be concordant or discordant, depending upon the relative cohesiveness of the color grouping. In the illustration on the right, the colors in (A) are in concord (highly unified), and in (B) they are in discord (disagreement).

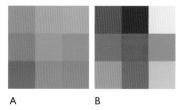

A B

COLOR INTERACTION

A color's quality is dependent upon its context because colors interact with each other where they meet. (See "simultaneous contrast".) In the example on the right, the color in the center of each square is physically identical, but it appears different in each context.

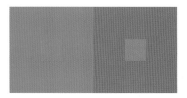

COLOR SYMBOLISM

Color symbolism is based upon automatic associations attached to particular colors or color combinations that are learned and largely culturally determined. In this way colors are linked to abstract ideas, e.g., love, mortality, authority, or nationhood, as shown on the right.

COLOR TEMPERATURE

When the hue continuum is represented as a circle, colors can be divided into cool and warm zones. The association of yellows, reds, oranges and yellow-greens with warmth, and violets, blues, and blue-greens with coolness is probably based on our physical experience in a world of fire and ice. Color temperature, like all aspects of color, is relative and contingent upon visual context.

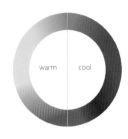

COLOR WHEEL

The color wheel is any circular depiction of the the hue continuum and has been used for centuries by color theorists. This version is divided into 12 major hues that include primary, secondary, and tertiary colors. (Primary hues are each subdivided into two "co-primaries".) In addition, the wheel is separated into four rings that indicate four levels of saturation: prismatic color, muted color, chromatic gray, and achromatic gray.

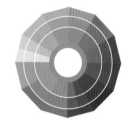

CMYK

CMYK refers to the colors used in four-color printing: cyan, magenta, yellow, and black (K).

COMPLEMENTARY HUES

Complements are any two hues that lie directly opposite each other on a color wheel. All hues have a complementary partner. When complements are intermixed, the resulting color is darker and duller than both of the two parent colors. When placed next to each other, their extreme difference makes for a strong contrast.

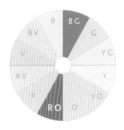

CO-PRIMARIES

Co-primaries expand the primary triad of red, yellow, and blue into three pairs that include warm and cool versions of each primary color. The use of co-primaries greatly extends the potential range of color achieved through their intermixture.

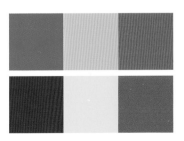

DARK TRANSPARENCY

Dark transparency is an illusionistic transparency wherein the color at the "overlap" is darker in value than both of the intersecting colors. The hue of the central color should blend that of each parent color equally. Dark transparency is effective when the two colors that appear to overlap are close in value.

EARTH TONE PRIMARY

An earth tone primary is a triad of earth tones, e.g. burnt sienna, yellow ocher, and Payne's gray.

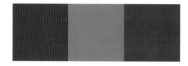

GAMUT

In computer terminology, a gamut is the range of hues available to a particular mode. The diagram on the right represents three color gamuts. The visible spectrum is represented by the large, solid shape, RGB by the pink triangle and CMYK by the area bound in yellow.

GRAYSCALE

The grayscale is a representation of the value continuum broken down into a finite number of steps. It usually consists of ten or so distinct and evenly progressing achromatic grays.

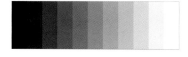

HIGH KEY

When colors in an image are "keyed" by value and the values are predominantly light, it is said to be in a high key.

HUE

One of the three structural factors of color (along with value and saturation), hue is the name given to a color to describe its location on the color spectrum owing to its particular wavelength.

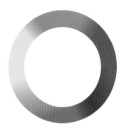

HUE CONTINUUM

The hue continuum is a graphic representation of the full color spectrum from infrared to ultraviolet.

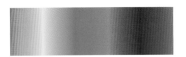

INHERENT LIGHT

Unlike luminosity, which is based on value and is measurable, inherent light is a visual quality that depends upon relative saturation and context. In the example on the right, the colors gain saturation as they move toward the center of the square, demonstrating a build up of inherent light at its nexus.

KEYED

Color groupings are keyed when they are brought together in either hue, value, saturation, or combinations thereof. In the illustration shown here, the colors are keyed by hue (they cluster around green and yellow-green) and by saturation (they are all muted colors).

LOW KEY

When colors in an image are "keyed" by value and the values are predominantly dark, it is said to be in a low key.

LUMINOSITY

Luminosity is light reflected from a surface; in color, it is tied to value. The lighter the color, the more luminous it is. This can be measured with a light sensor. In the example on the right, luminosity builds as the colors progress toward the center of the square.

MEDIAN TRANSPARENCY

Median transparency is an illusion of transparency wherein the value of the color at the "overlap" is midway between that of each parent color. The hue at the overlapping area should also appear to be an equal blend of the two outer colors. Median transparencies are most effective when the two colors that appear to overlap are diverse in value.

MONOCHROMATIC

Monochromatic color schemes are limited to one hue and variations thereof. They can have a broad range of values or saturation levels, as shown here.

MUTED COLORS

Muted colors constitute a zone in the saturation continuum that falls between chromatic grays and prismatic colors. Muted colors can be characterized as softer than prismatic colors, but they still display a clear sense of hue identity.

NONPROPORTIONAL COLOR INVENTORY

This is a selection of colors drawn from an object or image, usually one that has an uncountable number of colors. The inventory should be a summation of the color in the source that expresses its entire chromatic range as well as possible in a few tones.

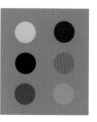

OPTICAL MIXING

Optical mixing occurs when small color fragments are fused by the eye to appear as seamless tonal transitions. As employed in tapestries and mosaics, the phenomenon relies upon the systematic progression of discrete tones. The optical mixture of myriad tiny dots of color is also the basis of four-color photo printing.

OVERTONE

Overtone is a term borrowed from music that describes the secondary hue bias or leaning of a primary hue. For example, alizarin crimson is a red that leans toward violet; it has violet overtones. Scarlet, another red, has orange overtones. An awareness of overtone is helpful in color mixing. The illustration on the right shows cool primary hues (crimson, lemon yellow, and ultramarine) surrounded by their overtone colors.

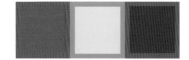

PRIMARY TRIAD

The primary triad is so called because it is indivisible and, in theory, all other colors (which are compound colors) can be mixed from it. The primary triad forms an equilateral triangle on the color spectrum when it is depicted as a circle.

PRISMATIC COLORS

Prismatic colors represent the hues of the spectrum. However, since pigment can never be as pure as light, prismatic colors are only an approximation of spectral color. They are, categorically, at the highest level of saturation.

PROPORTIONAL COLOR INVENTORY

The proportional color inventory is based on an object or image that has a countable number of colors. It represents all the colors present in their relative proportions.

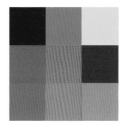
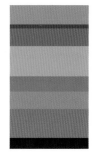

RETINAL PAINTING

Retinal painting focuses on the accurate rendition of the colored shapes that comprise a visual field and mimics the way the retina of the eye receives visual information. It emphasizes color over drawing and can be seen as an outgrowth of Impressionism and the ideas about optics that engaged artists like Monet, Pissarro, and others of their generation.

RGB

In additive or light color theory, red, green, and blue are considered the primary colors: RGB.

SATURATION

Saturation is the relative purity of hue present in a color. Highly saturated colors are very rich and have a strong hue presence. Colors that are low in saturation are dull and have a weak discernible hue. In this course we recognize three levels of saturation: prismatic color, muted color, and chromatic gray. In the image on the right, the colors of the square become more saturated as they move toward the center. Saturation is sometimes also called "intensity" or "chroma."

SATURATION CONTINUUM

The saturation continuum represents the infinite levels of saturation that exist between any two intermixed complementary colors.

SECONDARY TRIAD

The secondary triad consists of green, orange, and violet. Each of these colors can be mixed by combining two primary colors.

SHADE

A shade is the result of mixing any color with black.

SIMULTANEOUS CONTRAST

Simultaneous contrast is the optical effect that two neighboring colors have upon each other as their afterimages interact along a shared border. The image on the right illustrates the afterimages a violet and yellow-orange would project upon each other where they meet.

SPECTRUM

The spectrum is a phenomenon of light and can be seen in a rainbow or in the colors a prism casts upon a wall. It contains the full range of hues present in sunlight. See hue continuum.

SUBTRACTIVE COLOR

Subtractive color theory engages color as manifested by reflected, rather than direct light. The subtractive color primaries are red, yellow, and blue which, when intermixed, produce a dark, dull tone.

TERTIARY COLORS

These are also called "intermediate colors" and are yellow-orange, red-orange, blue-green, yellow-green, blue-violet and red-violet. In the illustration on the right, the tertiary colors at the top and bottom of the grid surround the three secondary colors that they are related to.

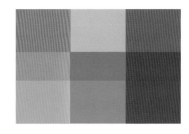

TINT

A tint results when any color is mixed with white.

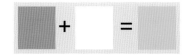

TONES

Tone is a somewhat generic term that can refer to any color but a prismatic color. All muted colors and chromatic grays are tones, as are all tints and shades.

TRIADIC

Triadic color relationships are comprised of any three equidistant hues on the color wheel. The two named triads are the primary and secondary triads. The illustration on the right shows the location of the primary triad on the hue spectrum.

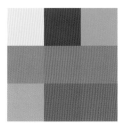

VALUE

Value is the relative quality of lightness of darkness in a color. It is the only structural factor of color visible in achromatic settings, as in black and white photography. Value means luminosity. In the image on the right, the colors become progressively darker in value (and less luminous) as they approach the center of the square.

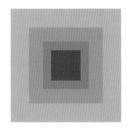

VALUE CONTINUUM

The value continuum is a graphic representation which suggests the infinite values that exist between black and white.

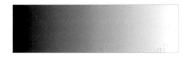

BIBLIOGRAPHY

Albers, Josef. *Interaction of Color*. New Haven, Conn.: Yale University Press, 1963.

Arnheim, Rudolf. *Art and Visual Perception*. Berkeley, Ca.: University of California Press, 1965.

Batchelor, David. *Chromophobia*. London: Reaktion Books, 2000.

Birren, Faber. *Principles of Color*. New York, N.Y.: Van Nostrand Reinhold Company, 1969.

Bloomer, Carolyn M. *Principles of Visual Perception*, New York, N.Y.: Design Press, 1990.

Chipp, Hershel B. *Theories of Modern Art*. Berkeley, Ca.: University of California Press, 1968.

Ferris, William. *Local Color: A Sense of Place in Folk Art*. New York, N.Y.: Anchor Books, 1992.

Flam, Jack. *Matisse on Art*. New York, N.Y.: E.P. Dutton, 1978.

Gage, John. *Color and Culture: Practice and Meaning from Antiquity to Abstraction*. Boston, Ma.: Bulfinch Press, 1993.

Goethe, J.W. *Theory of Colors*. Cambridge, Mass.: MIT Press, 1970.

Haftman, Werner. *The Mind and Work of Paul Klee*. New York, N.Y.: Praeger, 1967.

Itten, Johannes. *The Art of Color*. Translated by Ernst van Haagen. New York, N.Y.: Van Nostrand Reinhold Company, 1973.

Kandinsky, Wassily. *Concerning the Spiritual in Art*. Translated by Sadler. New York, N.Y.: Dover Publications, 1977.

Muncell, A.H. *A Color Notation: An Illustrated System Defining All Colors and Their Relations by Measured Scales of Hue, Value, and Chroma*. Baltimore, Md.: Munsell Color Company, 1905.

Newton, Sir Isaac. *Opticks, or a Treatise of the Reflections, Inflections & Colours of Light* (1704). 4th ed. New York, N.Y.: Dover Publications, 1952.

Ostwald, Wilhelm. *The Color Primer*. Edited by Faber Birren. New York, N.Y.: Van Nostrand Reinhold Company, 1969.

Rood, Ogden N. *Colour: A Textbook of Modern Chromatics*. London: Kegan Paul, Trench, Trubner & Co. Ltd., 1904.

Shorr, Harriet. *The Artist's Eye*. New York, N.Y.: Watson-Guptill Publications, 1990.

Sloane, Patricia. *The Visual Nature of Color*. New York, N.Y.: Design Press, 1989.

Tufte, Edward R. *Envisioning Information*. Cheshire, Conn.: Graphis Press, 1990.

Van Gogh, Vincent. *The Letters of Vincent van Gogh*. Boston, Mass.: New York Graphic Society, 1981.

Wollheim, Richard. *On Art and the Mind*. Cambridge, Mass.: Harvard University Press, 1974.

CREDITS

INDEX

INDEX (CONTINUED)